Baudrillard Reframed

Contemporary Thinkers Reframed Series

Deleuze Reframed ISBN: 978 1 84511 547 0
Damian Sutton & David Martin-Jones

Derrida Reframed ISBN: 978 1 84511 546 3
K. Malcolm Richards

Lacan Reframed ISBN: 978 1 84511 548 7
Steven Z. Levine

Baudrillard Reframed ISBN: 978 1 84511 678 1
Kim Toffoletti

Heidegger Reframed ISBN: 978 1 84511 679 8
Barbara Bolt

Kristeva Reframed ISBN: 978 1 84511 660 6
Estelle Barrett

Lyotard Reframed ISBN: 978 1 84511 680 4
Graham Jones

Baudrillard Reframed

Interpreting Key Thinkers for the Arts

L **Kim Toffoletti**

I.B. TAURIS

LONDON · NEW YORK

Published in 2011 by I.B.Tauris & Co. Ltd
6 Salem Road, London W2 4BU
175 Fifth Avenue, New York NY 10010
www.ibtauris.com

Distributed in the United States and Canada Exclusively by
Palgrave Macmillan 175 Fifth Avenue, New York NY 10010

ISBN: 978 1 84511 678 1

A full CIP record for this book is available from the British Library
A full CIP record for this book is available from the Library of
Congress
Library of Congress catalog card: available

Typeset in Egyptienne F by Dexter Haven Associates Ltd, London
Page design by Chris Bromley
Printed and bound in Great Britain by CPI Antony Rowe, Chippenham

Contents

Acknowledgements

I am indebted to Victoria Grace for her interest in this project and for reading and commenting on drafts of the manuscript. Our many discussions about Baudrillard's writing were invaluable to the development and refinement of my ideas, and enhanced the book immeasurably, although any errors that the reader might come across I claim as my own.

I would like to thank the School of Sociology and Anthropology at the University of Canterbury (New Zealand), who hosted me while I wrote this book. The collegiality and friendship of all the staff made my stay an enjoyable and productive one. Funding from Deakin University enabled me to take a sabbatical, and for that I am grateful. Thanks also to Susan Lawson and I.B.Tauris for commissioning me to undertake this project, and Philippa Brewster and Liza Thompson for seeing it through.

While in Christchurch, Magda and Grant provided a home away from home. Their wonderful dinners, excellent conversation and invitations to the rugby made for a memorable stay. Correspondence with friends and family back home kept me motivated. Special thanks to Eddy, Liz L., Pat, Lizzie T., Denny, Lisa, Caitlyn, Zac, Pamela and Brian for the emails, calls, visits, letters and photos.

Dan has contributed much to this book. As always, his useful advice and suggestions, especially with respect to pop culture events and occurrences, have made my writing sharper, more topical and focused. Without his commitment to me and my work I wouldn't be able to do what I do.

This book is dedicated to my parents Guido and Loretta Toffoletti, who have supported me always.

List of illustrations

Introduction

In November 2007, an Andy Warhol portrait of Elizabeth Taylor owned by Hugh Grant sold at a New York auction for 23.7 million dollars. The 1963 portrait, titled *Liz*, netted the actor a tidy profit of more than seven million dollars since he purchased it in 2001 (BBC News 2007). Aside from confirming the inflated state of the contemporary art market, this curious confluence of fame and image says something about the transformation of art into media spectacle. The event made news because of who was involved, while the merits of the artwork barely rated a mention. Some would deride the moment as a triumph of superficiality and surface. Jean Baudrillard, I suspect, would be drawn to this unholy trinity – an icon of pop art, a star of the silver screen and a foppish British cad – playing the game of simulation via the circuits of celebrity, image and culture. After all, wasn't it he who told us back in the eighties that image is everything and signs rule? He's also notorious for informing the world that the Gulf War didn't happen, well at least not as we imagined it did. In the popular mindset, Baudrillard's corpus of ideas has often been reduced to these two observations. Yet he has far more to offer in assessing the state of the world through our visual surroundings. Throughout his career his writing has addressed many aspects of visual culture and tackled a range of issues emerging from an image-based society.

Born in the French town of Remis, Jean Baudrillard (1929–2007) earned his academic stripes training under Henri Lefebvre. His reputation was forged amidst the French intellectual scene of

the 1960s, alongside contemporaries like Jacques Derrida, Gilles Deleuze and Michel Foucault. In later years he gained widespread appeal as a social commentator and critic, writing on all sorts of contemporary concerns like AIDS, reality TV, 'mad cow' disease, war and pornography. His ideas have influenced, among other things, the way that we think about the real, the virtual, communication technologies, consumerism and the media. For this reason, his writings are indispensable to a study of modern and postmodern image society.

This book sets out to explore the impact of Baudrillard's ideas in the visual arts and culture arena. It considers what he has contributed to studies of the visual, and the relevance and applicability of his theories to analysing images. It goes about this in two ways. Firstly, it unpacks Baudrillard's key ideas and approaches in the process of analysing visual texts. The images discussed in *Baudrillard Reframed* span the fields of visual arts and popular culture, drawing on examples from television, art, film and advertising. Secondly, it appraises Baudrillard's writings about our visual world of signs and images, of which there are many, including his influential theory of simulation and his thoughts on televised images of war, the fashion system, reality TV, advertising and contemporary art.

By introducing the reader to what Baudrillard has written about our changing visual landscape, as well as applying his key concepts to a range of examples, this volume offers a new perspective on his ideas. It shows that he is deeply invested in exploring the nature of representation, and highlights the significance of his contributions to understanding how the visual world operates. As well as offering us another vision of how image society works, Baudrillard reveals himself to be visually aware. Just as putting a new frame around a picture can change the way we see it, this series approaches well-known thinkers from a different angle, so that we might view them in a new light and perhaps with a renewed appreciation. But as anyone who has read

Baudrillard will know, his ideas don't always lend themselves to the most straightforward or obvious modes of interpretation and analysis. Attempting to 'frame' Baudrillard – to pin him down, set him up or catch him out – is a futile exercise. Why? Because a reader will never fully get to know Baudrillard's work by trying to approach it relative to existing cultural co-ordinates or an already-familiar set of values and meanings. Baudrillard sits outside conventional frames of reference.

This is most evident in the way that his later writings avoid interpretation, critique and judgement of the things they discuss – a strategy which tends to confound a Western tradition of critical analysis. He doesn't set out to solve problems, find solutions or reveal truths about images, or anything else for that matter. His thought process is a deliberate act of circumventing known categories through which we make sense of our world. In essence, his writing can be characterised as a reaction to the circumstances he finds himself in. The world of simulation, which we have come to know as our 'reality', is his critical point of departure. Provoked by his surroundings, he seeks an encounter with the other, always striving to elicit a response in turn. What is most significant about this process for Baudrillard is that it generates another point of engagement with the real beyond what we know and see. For him, the world 'as is' is not enough – play and appearances, paradoxes and uncertainties are necessary to jolt us out of set ways of interpretation and meaning. It is this unique take on the world that sets his writing apart from other critical thinkers of his generation. And it is in the process of our encounters with Baudrillard that the possibilities of his writings emerge – their power to challenge, incite, infuriate, provoke and seduce.

Just as Baudrillard's theoretical approach is grounded in the act of the encounter or exchange, so too does this strategy manifest in the way he writes. His distinctive style has been criticised for being confusing, unempirical, unsettling, whimsical and sensationalist (Rojek and Turner 1993: Introduction). Yet others

have noticed that Baudrillard's rhetoric belongs more to the realm of the playful and/or symbolic, which allows the words on the page to embody, or act out, his philosophy. One thing that most people agree on is that Baudrillard's writing strategy stands alone in the sense that it does not attempt to provide an answer to or interpretation of the images we come across, but entices us to think about the world and reality differently. To this end, I think it is important to quote Baudrillard directly when discussing his ideas, so that readers get a feel for his writing style. You will find quotes from Baudrillard dotted throughout this book. They sit alongside my explanations, which unravel what Baudrillard is saying and put his ideas into context. The aim of this strategy is to ease the reader into a relationship with Baudrillard's distinct form of commentary and encourage further reading and engagement with his texts.

What does it mean to approach images in a Baudrillardian fashion? *Baudrillard Reframed* endeavours to stay true to Baudrillard's spirit by avoiding the critical analysis of images in favour of encouraging the reader to look for points of departure, moments of reversal, events that capture the paradoxes he is trying to explain as they arise in the historical and contemporary visual landscape. I agree with Paul Hegarty when he says that 'Baudrillard's views, whether the reader believes them to be right or wrong, are very difficult to put to use, or to apply directly' (Hegarty 2004: 2). A Baudrillardian take on the visual means necessarily avoiding using his ideas simply as analytical tools that can be applied to images in order to make sense of them. His writing demands far more than that. If there is one lesson we can take from Baudrillard's philosophy, it is to endeavour to work outside established categories of knowledge and meaning in our visual encounters.

Now that we have an idea of where Baudrillard is coming from conceptually, we need to ask 'what place does Baudrillard currently occupy in the realm of visual arts and culture?' For many,

Baudrillard's notion of simulation would be considered his most notable contribution to theories of the visual. His writings appear in most undergraduate courses that engage with popular culture, providing a reference-point from which to examine the operation of signs in a postmodern age. The influence of his theories on contemporary society can be seen in a number of artworks and art movements, especially throughout the 1980s. Artists like Jenny Holzer and Barbara Kruger produced imagery that expressed a concern with the processes of sign exchange in an era of hyperreality, while simulationist artists sought to embody Baudrillard's ideas through their practice. His theory of simulation also pervaded the mainstream in the form of films like the *Matrix* trilogy and via the cyberpunk scene. Baudrillard has commonly been aligned with proponents of postmodernism like Jean-François Lyotard and Frederic Jameson who chart the shift away from the certainty of modernist grand narratives and coherent categories through which to order and understand the world. In its place is substituted a pluralism of styles, a collapse of aesthetic values and hierarchies, and an interrogation of the distinction between 'representation' and 'reality'. It is in light of this cultural turn that the concepts of simulation and hyperreality have formed the cornerstone of much of the scholarship on Baudrillard and the visual to date, particularly in the fields of cultural production and art criticism. This is irrespective of Baudrillard's insistence that he has 'nothing to do with postmodernism' (Baudrillard cited in Zurbrugg 1994: 227).

Despite the impact of Baudrillard's thought on conceptualising signs and images, especially in a postmodern era of hyperreality and the digital age, no book-length study has been dedicated to tracing Baudrillard's ideas as they have engaged with the visual spectrum. This is a profound omission when we consider the amount that Baudrillard has written about visual artefacts and communication modes over many years. There are, however, instances where Baudrillard's theories have been employed to

analyse a variety of visual modes and imaging technologies. These include, but are not limited to, studies of film,[1] photography,[2] TV programmes,[3] medical-imaging technologies (Grace 2003) and contemporary art.[4] I encourage you to seek out these and other Baudrillard-inspired texts to grasp further Baudrillard's relevance to studies of the visual.

Given that an emphasis on the visual underpins this book, it is necessarily structured quite differently to other surveys of Baudrillard's output, some of which I have listed in the 'Further reading' section. Typically, Baudrillard scholars undertake their analysis chronologically – by assessing Baudrillard's earliest publications through to his most current ideas. This approach has proved effective for a number of reasons. It allows the reader to follow the changes in Baudrillard's thinking over time, systematically evaluate the evolution of his ideas, interpret his assertions within the historical, socio-political context in which they were written, and align his work with that of other major theoretical players and schools of thought.

For the purposes of this study, however, a different approach will be taken. I have chosen to discuss Baudrillard thematically, with each chapter-heading corresponding to a major focus of his writing. These themes – the image, art, consumption and screens – were devised to allow for a neat alignment between a number of prominent ideas in Baudrillard's body of work and some common sites of visual analysis. Organising the book this way allows me to bring together a range of Baudrillard's writing on a particular topic under one chapter heading. For example, Baudrillard's observations on consumer society have appeared in various books, articles and interviews across the decades. By amassing and analysing his writings on consumption in a single chapter, we can chart his reactions to the constant shifts and trends in the fields of fashion and advertising. Through this process, what we find is that as things change, so do Baudrillard's responses. Don't take this to be a sign of inconsistency on

Baudrillard's part – he hasn't changed his mind. Rather, it demonstrates his philosophy that a meaningful encounter with images in particular contexts, circumstances and points in time should generate something beyond what existed before. And if it doesn't, then we need to ask why. In many instances Baudrillard's writings anticipate where the world is heading. He thinks the future and it has already happened. When read in retrospect the accuracy of many of his predictions are not only unnerving, but demonstrate his act of speculating on things in order to elicit provocation; to make us think beyond established paradigms of thought. Another reason for adopting a thematic approach – like consumerism – is that it allows us to dissect Baudrillard's ideas alongside a common visual vocabulary that also seeks to scrutinise the impact and effects of consumer society. Through the process of locating his ideas in the context of visual examples, we can better understand their significance and relevance to the visual field, and vice versa.

We could say that the structure of this study tends towards the genealogical. Inspired by Foucault (Foucault 1984), a genealogical mode of analysis allows for novel connections to be made across Baudrillard's writings over time. Rather than charting his intellectual contribution in terms of a linear progression of ideas, I search for affiliations across his body of thought. While recognising the benefits of chronologically addressing each stage of Baudrillard's writing, I think that a thematic approach gives us an alternative method through which to interrogate his ideas and highlight their relevance to the visual arts. It also allows us to see more clearly where Baudrillard's ideas depart from conventional approaches to analysing images and signs. What we find is that his emphasis on our encounters with images, rather than the formal qualities of the image itself, pushes the methodological and theoretical boundaries of visual analysis.

The first chapter is designed to introduce readers to the central concepts in Baudrillard's writing on signs and images, and put

these ideas into context. I will consider his claim that culture has become 'transaestheticised', and through this process argue for the relevance and influence of Baudrillard's thinking to an understanding of our visual world. By offering an explanation of the four orders of simulacra, from Renaissance painting through to digital image-making, this chapter describes how the role and function of images have changed over time.

The purpose of Chapter 2 is to consider critically Baudrillard's take on art and the operations of the art world. As a photographer and public intellectual, what does Baudrillard have to say about the role and function of art? By identifying and assessing his writings on this topic, the significance of his ideas for art practitioners, students, consumers and critics can be gauged. Three contemporary British artists – Tracey Emin, Merlin Carpenter and Banksy – are analysed in the light of Baudrillard's claims that contemporary art is 'null' and we are in the midst of an art-world 'conspiracy'. This chapter argues for the necessity of Baudrillard's commentary on art to our understanding of visual culture more broadly, because it forces us to re-examine accepted ways of understanding images, and in the process raises new questions about the extent to which we can speak about representation and reality as unproblematic terms.

In the next chapter – Chapter 3 – Baudrillard's long-standing preoccupation with consumer culture and lifestyle will be explored through a study of fashion and advertising. Here I focus my attention on the advertising campaigns of couture houses like Chanel and Louis Vuitton to help explain foundational ideas in Baudrillard's study of contemporary consumer culture, and assess the impact of images on the formation of identities and lifestyles. Consumer trends, including Burberry check, 'dumpster-diving' and placement advertising are also examined through a Baudrillardian lens.

Chapter 4 turns to Baudrillard's writings on mass media and communication technologies. How does Baudrillard understand

the role of images in film, television and online? It takes a closer look at Baudrillard's observations about the reality TV series *Big Brother* to explore what happens at the screen interface when the viewer is simultaneously 'spectator' and 'participant'. Here I show how Baudrillard's commentary on virtual and 'integral' reality has influenced our understanding of a digitised world where space, place and time have been radically transformed. Perhaps Baudrillard's most controversial and topical writing is on postmodern warfare and its representation in the mass media. This chapter concludes by analysing his writings on war, terrorism and globalisation through the lens of Hollywood films about the Iraq War.

By documenting Baudrillard's engagements with the visual spheres of the art world, consumer society and mass-media technologies, what emerges is a renewed vision of Baudrillard's legacy – one that reveals the complexities of theorising the visual in his terms (fatal, dual, singular), and illuminates the possibilities for images in a world in which he insists there can be no representation. The process of undertaking this survey has reinforced my belief that we need Baudrillard's radical thought as urgently as ever. Baudrillard died in the year before I started writing this book. This intellectual contribution offers an opportunity to scrutinise his body of thought, assess the impact of his ideas, and gauge their applicability to theorising current events and debates around the operations of the visual field.

Chapter 1

The image

Introduction

The Australian art scene was sent into a spin when police raided an exhibition of photographs by internationally renowned artist Bill Henson. The offending artworks – seized as suspected child pornography – depict nude, underage boys and girls. The children in question are understood to have consented to model for the series with the approval of their parents (Wilson and Trad 2008). For those who are unfamiliar with Henson's photographs, they often depict teens in various unclothed and semi-naked poses amidst gloomy settings. Up until now, what has made his works unforgettable is not so much his subject matter but his use of *chiaroscuro* – contrasting light and dark elements – to generate a dual effect of beauty and unease. For more than 25 years Henson has been exploring the darker aspects of the transition to adulthood, rendering the not-quite-childlike but not-yet-adult subject in a series of large-scale, haunting studies. At the 49th Venice Biennale his depictions of pubescent, sometimes androgynous, bodies showed to much critical acclaim but no discernible public outcry. Before this incident no one seems to have complained about his artworks, which are held by major galleries in Australia, as well as overseas.

After what happened at the Sydney gallery in May 2008, where more than 20 artworks were confiscated, Henson's pictures were denounced by the Prime Minister of Australia, among others. To be sure, Henson isn't the first artist to be accused of sexualising

children and young adults. American photographers Sally Mann and Tierney Gearon courted controversy by exhibiting nude pictures of their own offspring throughout the eighties, nineties and beyond. Jock Sturges and David Hamilton's photographs depicting unclothed adolescent females have provoked accusations of child pornography. In the nationwide media debate that ensued from the Henson affair, a number of commentators pointed out that representations of naked children have long been a part of the Western art canon. Sharing this view is noted feminist Germaine Greer, who remarked:

Renaissance paintings are festooned with the naked bodies of babies displayed in the most fetching of poses; small naked boys sit splay-legged on the steps of temples and astride beams and boughs. The public that saw them included pederasts and pedophiles, but nobody deemed that a reason for not showing them. The Christ Child sat astride his mother's knee displaying his perfect genitals. Though dirty old priests might have taken guilty pleasure from contemplating them, the rest of us are still allowed to see them. More reticence is observed with female figures, mainly because female models were hard to come by, but the first genuinely female nudes were often pubescent or prepubescent. The closet Venuses of Cranach and Baldung, for example, have the undeveloped hips, small, hard, high breasts and pallid nipples of 13-year-olds. Botticelli's Venus is hardly older. Greuze's girls, with their white bosoms glimpsed through disordered clothing and tear-filled eyes, are not only very young but violated as well. Bouguereau's *Cupidon* (1875) and *Child at Bath* (1886) are far more disturbing images of vulnerable immaturity than anything created by Henson, but paint may do what photography may not. If Henson had painted his young subjects, the police would have no situation to investigate. (Greer 2008)

This last point is important, I think. Even though there might have been a time when Henson's subject matter would have been considered acceptable, the way these images are produced – as photographs – adds another layer of complexity to this debate.

Often, we tend to think of photographs as factual – as having a certain indexical connection to the 'real' world. This correlation, while questionable, has been used to distinguish the mediums of photography and painting, with the latter commonly viewed as illusory or further removed from reality, in part through its association with the realms of the artist's imagination, creativity and uniqueness. So an element of the anxiety generated by Henson's images is due to their status as photographs, which in the minds of some people are 'evidence' of reality, as well as too easily reproducible and distributable.

The locations where these images are consumed play a part, too. You don't need to visit a gallery any more to see artworks like Henson's, which can be easily accessed on the Internet, alongside a host of other images of children produced for commercial consumption – or, more troubling, for sexual gratification. Changing modes of dissemination and reception add to the confusion between art and pornography, as well as other visual forms, for that matter. The response to Henson's photographs also needs to be understood in light of increased awareness of child sexual abuse and a growing concern over the sexualisation of children in popular and consumer culture. Remember, Henson has been taking photos like this for many years without controversy, yet recently his practice has been considered unacceptable by some groups as a society's views on childhood start to shift.

What this example illustrates is how social, cultural, political and technological changes have altered the way images are made, as well as how they circulate and how we make sense of them. It raises valid and important points for debate about the ethics and legalities of image-making, as well as what constitutes art. Incidents like these force us to confront the status of the image in today's world. What function do images serve? How do we understand the role and circulation of images – photographs, cartoons, computer-generated images (CGI), paintings, film and the

like? How might we distinguish between different types of images? Is this possible? Or desirable? And how do we resolve matters when the lines between art and mass culture become blurred? This chapter is designed to introduce readers to the changing nature of the image, in order to help us make sense of these kinds of debates occurring within the visual arts, and the realm of image culture more broadly. Baudrillard's writings, especially his notions of the simulacra, hyperreality and the transaesthetic, can give us some clues as to how images have worked historically, and the changing relationship between 'representation' and 'reality' which have led us to where we find ourselves today – in an era characterised by simulation and virtuality.

Transaesthetics

One of the ways that we can think about the Henson incident, and other examples like it, is in terms of what Baudrillard has described as transaesthetics. Defined by Baudrillard as 'the moment when modernity exploded on us' (Baudrillard 1993b: 3), there are certain characteristics he attributes to the transaesthetic. Firstly, it is typified by 'the mixing up of all cultures and all styles' (Baudrillard 1993b: 12). Baudrillard says that it is getting harder to distinguish clearly between art and other visual forms in contemporary culture because the categories used to separate things from each other have started to crumble. In the case of Henson's photographs, they aren't solely interpreted as art because their content – the naked body – also associates them with pornography. In another way, Henson's images resemble glossy magazine advertisements, with both employing the medium of photography to construct their images. The translucent skin of the subjects he depicts glisten against their dark backdrops in a way that is not dissimilar to that of styled, angular fashion models. Indeed, the criticism of Henson's use of young girls has been that it is the equivalent of the fashion industry's. His pictures have been likened to film stills, and often appear in magazines, as well as on

the Internet, which complicates the distinction between art and commercial culture even more. Just as his photographs capture the zone between day and night, male and female, sinister and seductive, adult and child, so too do they defy easy classification.

Henson's photographs also support Baudrillard's claim that the transaesthetic moment is one where everything has become aestheticised – that is, manufactured into a sign for consumption. To illustrate his point Baudrillard gives the example of politics being turned into a spectacle. As occurred with the American electoral primaries of 2008 that saw Hillary Clinton pitted against Barack Obama for the democratic nomination for president, policies and principles are subsumed by a focus on appearances to the extent that looks become a signal of reliability, trustworthiness and suitability. To quote Baudrillard,

everything aestheticises itself: politics aestheticises itself into spectacle, sex into advertising and pornography and the whole gamut of activities into what is held to be called culture, which is something totally different from art; this culture is an advertising and media semiologising process which invades everything. (Baudrillard 1992:10)

Baudrillard refers to this aestheticisation of all objects and forms as the 'Xerox degree of culture' (Baudrillard 1992: 10). Returning to the example of Henson's photographs, we could argue that young adulthood, androgyny, or even art itself is made over as a sign to be consumed visually alongside a parade of other symbols and representations. We interpret these artworks in relation to the images we are familiar with from other visual sites, like cinema, pornography, fashion advertising and the history of Western art. This confused cultural space where Henson's photographs are produced and received reflects the postmodern breakdown of the divide between high art and low or mass culture – a defining feature of the cultural condition of late capitalism (Jameson 1991: 112).

Not only does the subject matter of Henson's photographs confound catergorisation, but the spaces in which they circulate further complicates their status. Along with the invasion of all genres and styles by each other, the transaesthetic is bolstered by the circulation of images in diverse spaces and across vast distances, enabled by instantaneous, immersive, mass-communication technologies like the Internet. Unlike the days when one went to a gallery to look at art, globalised media has made art much more accessible and reproducible. No longer confined to, or contained within, a particular place, it can reach more people in more locations than ever before. The flipside, though, is how can audiences be sure that what they are looking at is art when it is not defined by its gallery context? What's more, in true DIY style, the interactive nature of new technologies enable almost anyone to create and disseminate 'art' (Poster 2006: Chapter 11). As a result of these shifts in how images are made, interpreted, circulated and consumed, there is more and more uncertainty about which images serve what functions, for whom, and in what contexts. This leads us to wonder, 'What counts as art?'

A critical point that Baudrillard makes about this transaesthetic state of affairs is that as the distinction between forms and genres become less and less defined, making aesthetic judgements about what is good or bad, beautiful or ugly, tasteful or crass, also gets harder. This poses a problem for how we can meaningfully speak about art when it has 'disappeared' as a coherent category, and prompts us to question whether old modes of analysis can work effectively in this situation. I consider this dilemma in greater detail in the next chapter.

While it is useful to consider the production and circulation of images in an age of globalisation and information technologies, it is equally necessary to recognise that we have not always thought about images in these terms. In what is perhaps Baudrillard's best-known book in the context of visual culture and the performing arts – *Simulacra and Simulation* – Baudrillard

demonstrates that images have served different functions throughout history. The image has changed from reflecting reality, to masking reality, to masking the absence of reality, to having no relation to reality whatsoever (Baudrillard 1994b: 6). But even before he traced these phases, Baudrillard identified the changing status of the image in *Symbolic Exchange and Death* (1993a), where he proposed three orders of simulacra (meaning 'appearance' or 'likeness') to describe the different ways that images have been produced, circulated and used, and our relationship to them. A fourth order has since been added. The rest of this chapter will consider the four classificatory orders of simulacra that Baudrillard proposes. By contemplating the purpose of images in society – and crucially, their value – Baudrillard's theory of the simulacra can help visual arts proponents understand the role images play in moulding perceptions of reality and its representation.

First-order simulacrum

When Baudrillard talks about the first order of the simulacra, he is referring to the period from the Renaissance to the Industrial Revolution. Of course images existed prior to this, yet according to Baudrillard they occupied a pre-modern era of social relations characterised by 'symbolic exchange' – a time before objects accumulated value in the economic or aesthetic sense that we are familiar with today. Baudrillard explains that images used to play a part in ritual, like the icons of Byzantine art, whose circulation was restricted to their sacred function (Baudrillard 1993a: 50). Each icon had a specific purpose and singular importance in forging collective ties through rituals and ceremonies. It is during the Classical period that Baudrillard claims the social function of the sign changes from one of maintaining social relations to one of hiding the fact that signs can no longer play that particular role in a world based on universal or generalised value systems. Put

simply, he is saying that images have moved from being ritualistic to aesthetic.

In order to grasp better this distinction, let's turn to a well-known example from Western architecture during this period – the Jesuit church of Sant'Andrea al Quirinale in Rome, built from 1658–78 (Figure 1). Designed by Gian Lorenzo Bernini, the interiors of this structure display the hallmarks of Baroque architecture. Based on an oval floorplan, its centrepiece is a high altar illuminated by a flood of yellow light streaming in from a magnificent dome overhead. The structure is richly decorated throughout with red marble, gold detailing, intricate sculptures and elaborately tiled floors. Its ornate arches and cornices, as well as its domed roof, give the building its sculptural qualities, as well as fostering a sense of grandeur and awe at the pure spectacle of such frivolous embellishments. By overwhelming the senses with a riot of ornamentation, Sant'Andrea al Quirinale masks the fact that at its heart is a symbolic loss. For Baudrillard, in the first-order simulacrum the sign or image can only simulate the 'symbolic obligation', or worth it once had, that was generated by its sacred and specific role. That is, images no longer foster ritual relations but instead connote status – they now work to spread religious devotion, 'aiming at control of a pacified society' and cementing the power of the Church (Baudrillard 1993a: 53).

The Baroque excess and theatricality of Sant'Andrea al Quirinale also illustrates the changing nature of the image from something that was once restricted and limited in its circulation to something that is made increasingly accessible via public display. The plethora of paintings, frescoes and sculptures throughout the church and its side chapels is an example of a trend observed by Baudrillard whereby images are being made readily available to the masses. For Baudrillard, this explosion of images is directly associated with the loss of symbolic exchange that characterised ritualistic and feudal societies, and the subsequent emergence of a semiotic order of value in which images and signs function to

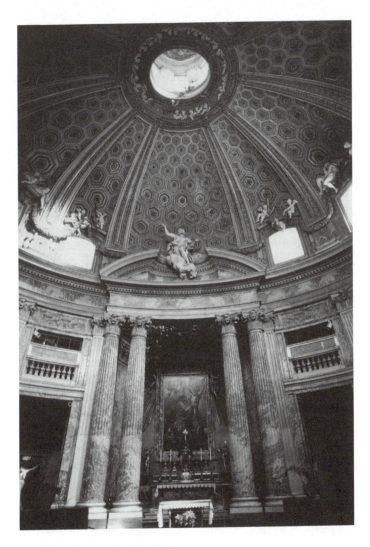

1. Gian Lorenzo Bernini, 1658–78,
Church of Sant'Andrea al
Quirinale (Rome).

homogenise and order the individual, random and unique aspects of the natural world. Signs are accorded a referent in nature – they are interpretations of the world, and hence allow for an arbitrary relation between a signifier and signified to be forged.

According to Baudrillard, as the image loses its anthropological status and becomes aestheticised it must accrue value in another way, which is by 'giving the appearance that it is bound to the world' (Baudrillard 1993a: 51). During this phase of simulation, Baudrillard notices that representations aim to reproduce nature in the form of an imitation. We can see this in stucco, a type of plasterwork that enables the rendering of objects in three dimensions, and which is a defining feature of Baroque décor. Nestled around the dome of Sant'Andrea al Quirinale are groups of stucco *putti* – or cherubs – among fruit and flowers. And while decorative objects like the cherubs and ornamental flora of the church's interior don't look necessarily look 'natural', they function to create a sense of universal order, harmony and mastery via the re-creation or imitation of the world. Baudrillard refers to these image-objects as counterfeits, or corrupt symbols, to paraphrase Gary Genosko, that are noticeably different from the object that they are trying to copy (Genosko 1994: 42). It doesn't matter that the stucco features used in Sant'Andrea al Quirinale are not realistic. In fact, it is because this ornamentation is so overt and over-the-top that it is able to proclaim its status as a copy – *not* the real thing – hence playing with representation. In this sense, the counterfeit and the original are analogous, so that the difference between the image and its referent is obvious to the viewer.

Second-order simulacrum

The second-order simulacrum that Baudrillard identifies is ushered in by the Industrial Revolution. With the onset of techniques of mass-production, the way objects and images are made changes, and accordingly so does their value and function. We can witness this shift in the rise of commercial and consumer

culture, as well as in the manner that art is created. Even the many great artworks of this period that aren't generated by mechanical means belong to an order of signs founded on a system of serial production, accruing meaning relative to a capitalist economy of value exchange. Unlike the images and objects of the Classical period just discussed, whereby the rendering of the object relied on an element of playing with appearances, Baudrillard reckons that reproduction on an industrial scale starts to erode this association between the image and the world it depicts. In the second order, production has taken over play as the force that underpins our relationship to images, leading to a situation where images no longer aim to resemble or compare with something. Rather, objects and images are made in order to generate equivalences with the things they depict, and come to be understood relative to each other.

Andy Warhol's *Campbell's Soup Cans* of the 1960s can help to illustrate the characteristics of the second phase that Baudrillard has identified. These artworks have become so iconic in the history of Western art that they hardly require description. Even those of us who have never eaten Campbell's soup are likely to associate the brand with Warhol's silkscreen renderings of the red and white label with its little gold seal. New York's Museum of Modern Art (MoMA) is where you can find Warhol's *Campbell's Soup Cans* of 1962 – an artwork that is made up of 32 canvases, each approximately 50cm by 40cm. Each canvas depicts one can, which fills the entire frame. Why 32, you might ask? Apparently, this was the number of flavours that Campbell's sold in its soup range when Warhol was producing his work. Hence each canned product, while identical, is labelled differently, from 'Bean' to 'Clam Chowder', 'Split Pea', 'Tomato', 'Chicken' and so on.

By depicting regular, consumer objects as his subject matter, Warhol reveals a preoccupation with the commodification and massification of culture. In both content and form, *Campbell's*

Soup Cans echoes the serial reproduction of the commodity, or second-order phase. The way these canvases are hung creates a sense of homogeneity and uniform equivalence. Each can is displayed in serial order – one after another and on top of one another – giving the impression that the cans are sitting on a supermarket shelf, or have just come off a production line. Just as a can of Campbell's chicken soup from the grocery store is identical to the one sitting next to it, Warhol's cans are identical signs, with any canvas substitutable with another. Because each product can stand in for or be replaced by another, they are understood to be equivalent to one another. What we see occurring here is 'a technical principle where the machine has the upper hand, and where, with the machine, *equivalence* is established' (Baudrillard 1993a: 53).

This sense of equivalence is due also to Warhol's reliance on industrial modes of production to create his artworks. Even the name of his studio – the Factory – gives away his interest in automated and mechanical processes. Each image of a soup can is printed from a silkscreen template, making it uniformly like every other can derived from the same template. This means that not only is it impossible to distinguish between one object and another, but there is no 'original' can from which the rest have been copied. For Baudrillard, it is the moment when the 'possibility of two or *n* identical objects' can be realised:

In the series, objects become indistinct simulacra of one another and, along with objects, of the men that produce them. The extinction of the original reference also facilitates the general law of equivalences, that is to say, *the very possibility of production*. (Baudrillard 1993a: 55)

In this quote Baudrillard also prompts us to consider the way images are produced, and by whom. In the instance of Andy Warhol, the mechanised techniques of reproduction he employs complicate the idea of the artist as a unique figure in the creation of an artwork. Anyone can do the job of applying paint

to a silkscreen template, and it is common knowledge that Warhol's hand didn't touch every painting produced under his name. This leads us to wonder about the originality of the artwork, and calls into question the role of the artist. Even though Warhol might have drawn the soup can that forms the basis of these pictures, his design is not original, in the sense that it is a copy of a well-known commercial brand. These manoeuvres are significant because they confound the idea of an original reference and prompt us to question the distinction between high art and consumer culture. The use of commonplace, everyday products in Warhol's art shifts our focus away from what is being represented (which is familiar to us to the point that it doesn't register as unique or novel) towards how it is represented (the use of repetition via mechanical means).

The idea of the artwork as original and unique is also challenged by Warhol in the way that he continued to deploy serialised imagery of soup cans to produce multiple versions, including *100 Campbell's Soup Cans* (1962) and *200 Campbell's Soup Cans* (1962). Given that they depict a motif derived from the same template and technique, it becomes difficult to ascertain which of these artworks is the 'original' or definitive version in the series.

To sum up, for Baudrillard, exchange value is the defining feature of the commodity stage. Because objects can be serially reproduced *ad infinitum*, this allows for the exchange or substitution of one for another. They are valued as object-signs in a marketplace – an idea I take up in Chapter 2 when discussing art auctions and in Chapter 3's study of signs in consumer society. The difference between the first and second orders is that the first stage creates an analogy between the original and fake (the image is an interpretation of the world), while in the second order they are equivalent (the image seeks to be equivalent to what it portrays). In both instances there is a lingering sense that reality is still somehow different to the image – stucco fruit

is fake when compared with real fruit, while actual soup cans are the pre-existing standard from which the representational version derives its value. But in the third phase this changes. This is the moment when the real object is understood to be just as much of a simulation as the fake one (Grace 2000: 107).

Third-order simulacrum

The third order is the one that most people would associate with Baudrillard's thinking, and from which we derive our popular understandings of hyperreality and simulation, which readers are likely to be familiar with. It is in the third schema that any discernable distinction between images and reality begins to fall away completely. What has precipitated this shift in how images function? Capitalism and consumer culture, mass media and communication technologies have aided the proliferation and multiplication of images in a way never experienced before. Our visual spectrum is choked up with a seemingly endless stream of images, brands, slogans, signs, graphics and labels. We are at the point of hyperreality, says Baudrillard, when our knowledge and understanding of the world is primarily derived through signs that have come to replace reality (Baudrillard 1994b: 2). Under these conditions, images circulate freely, detached from any concrete association with an object in the 'real world', hence can only accrue meaning in relation to each other. I will tease out these ideas in the rest of this chapter, as well as continue to apply them throughout the book to a range of popular images drawn from the fields of fashion, art, television and film.

Right now we can look to the phenomenon known as the '*CSI* effect' to illustrate how images work in the third phase. The *CSI* effect is a term used to explain the way that TV shows like *CSI: Crime Scene Investigation* and various forensic programmes influence how people perceive the process of solving crimes. Not only are criminals 'learning what not to leave behind at crime scenes' by watching these shows (Borger 2006), but jurors develop

certain, often unrealistic, expectations of the role of forensic evidence in trials. These perceptions of how 'real life' should be are generated from TV images. When crimes are reconstructed in a series like *CSI* (and its various spin offs, *CSI New York* and *CSI Miami*) all the action is compressed into a 60-minute slot so that the elements of a forensic investigation become more glamorous, exciting, immediate and probing than real life (Figure 2).

At the crime scene, experts interpret dramatic blood spatter patterns and deploy impressive-looking infrared machines to locate invisible blood traces. Back in the lab, important-looking people extract DNA samples from evidence, run a series of tests using state-of-the-art technology, and in a matter of moments declare that they have 'found a match'. Each step in the gathering, analysis and evaluation of evidence is visually documented in a way that attempts to bring us closer to the truth. Some sequences aim to draw the viewer so close that they go inside the victim's body. These scenes occur in the context of the CSI team hypothesising about the cause of death of a particular person. The descriptions offered by the investigators are accompanied by gory visuals showing, for example, the trajectory of a bullet as it enters the victim and tears through their internal organs. We hear the squelch of soft flesh being penetrated. Like the bullet going inside the body, we enter into the image. This level of detail, where the viewer is brought into the body/image, is emblematic of the extent to which forensics immerses us in a hyperreality – a way of experiencing contemporary life that is more real than reality itself – so much so that there is no original to compare it to (Baudrillard 1994b: 2).

CSI upholds the illusion of reality by coming across as fiction, in a bid to encourage us to think that the world beyond the TV screen is somehow 'realer' in comparison. It has all the hallmarks of a big-budget drama, with high production values, polished editing, attractive stars and impressive special effects. After all, we are talking about a Jerry Bruckheimer creation here. *Crime*

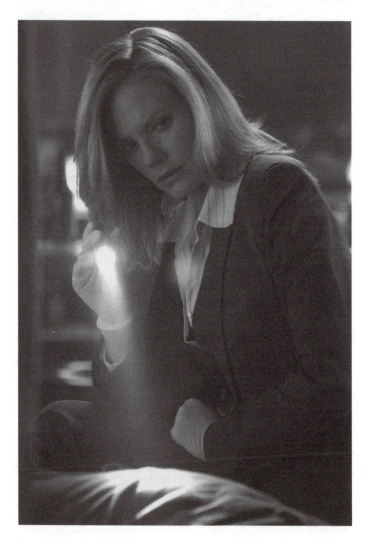

2. *CSI: Crime Scene
Investigation*, TV still.
Dir. Jerry Bruckheimer.

Scene Investigation does not aim for gritty realism, or documentary style, but proclaims itself as a sexier, slicker take on the TV crime genre, as well as a more exciting version of real life. But this line between reality and illusion blurs when those watching it, which include prosecutors and police officers, are influenced by the show to the point where it serves as a model of how they think they should carry out their duties. According to Paul Rincon, as a result of shows like *CSI*, much more evidence is submitted to forensic laboratories, causing a backlog in processing (Rincon 2005). The prosecutors want DNA evidence to present at trial because they have observed that without it a jury is much less likely to convict. Having watched these crime programmes, jurors expect to receive objective, scientific, DNA proof. And they are troubled when it isn't available immediately, or at all. Victims' families have also expressed dissatisfaction at the long waiting times involved in accruing and processing forensic evidence for the courts. Under the influence of television, in their minds evidence can be swiftly gathered and results obtained in an instant. Whether or not it is true that the *CSI* effect is a factor in generating increased volumes of evidence is not the main issue here. Indeed, it would be difficult, if not impossible, to establish if this were the case. Rather, it is the perception that the *CSI* effect is what is constructing our reality that matters.

What is occurring here has been described by Baudrillard as the '*precession of simulacra*' – a concept which is crucial to understanding how the third phase of simulation works (Baudrillard 1994b: 1). The reference-point for the realness of forensic evidence is a model derived from televisual depictions of a crime team at work. In many instances, people, including prosecutors, jurors, victims' advocates and police believe real forensic evidence to be something that is instantly available and accurate. That way, there is no room for doubting the innocence or guilt of the accused. As *CSI*'s chief forensics expert Gil Grissom

is fond of saying, the evidence doesn't lie. Yet strangely enough, the model of forensics provided by the show is itself modelled on viewer preferences and TV ratings, which are themselves what Baudrillard would describe as a 'simulacrum of public opinion' (Baudrillard 1993a: 65). *CSI* follows a code for popular television viewing, which in simple terms gives audiences scenarios that are easy to follow, visually appealing and that they are familiar with. Crime shows often borrow from real life and vice versa (Jermyn 2007: 173). Sometimes the storylines are based on past crime events, which have in turn spawned copycat killings. In other cases, events occur on the show that are seemingly unlikely to happen in 'real life', yet subsequently do. *CSI* has even spawned imitators in the form of 'real crime' programmes, which employ similar techniques to those used by the drama genre in re-enacting or reconstructing past police cases. Drawing on the popularity of crime dramas like *CSI*, these 'factual' shows unravel the case by presenting the viewer with forensic expertise and diagnostic techniques, allowing for the neat resolution of the case by the end of the programme. This curious confluence of reality and the screen occurs, Baudrillard says, because in the state of simulation 'we are all obliged to replay all scenarios precisely because they have all taken place already, whether actually or potentially' (Baudrillard 1993a: 4). While it used to be the case that images had a power in their ability to be unique, imaginative and novel, Baudrillard argues that this rarely happens now. Instead, 'At this level, the question of signs and their rational destinations, their "real" and their "imaginary", their repression, reversal, the illusions they form of what they silence or of their parallel significations, is completely effaced' (Baudrillard 1993a: 57).

Compared with the first and second orders, which maintain the object and its representation as separate things, the third order complicates this way of viewing the world. This is because images are no longer different from reality, but generate our sense of reality by making us think that the stuff outside the frame is

the real thing. The purpose of this strategy is to hide the fact that there is no true or authentic reality, only the simulation of reality. To quote Baudrillard himself, *'the simulacrum is not that which hides the truth, but that which hides the absence of truth'* (Baudrillard 2005c: 32). In this respect, the system of simulation is all-encompassing. In the third order of simulacra, images are our reality and the code is the 'new *operational* configuration' of the production of the image (Baudrillard 1993a: 57). We need to be wary, though, of interpreting this concept as meaning that material objects and people and feelings don't exist any more. This is not Baudrillard's position. Rather, simulation brings about a shift in our idea of what reality is. As the *CSI* effect demonstrates, our perception of forensics is generated by televisual images alongside other signs, which in turn are influenced by preconceived ideas of the needs and wants of viewers of TV crime. To complete the loop, simulated crimes on the TV screen produce very real and tangible effects – criminals respond by more carefully covering their tracks, and jurors have higher expectations of forensic evidence. In this way we can see how images on the TV screen, like the *CSI* series, generate our perception and experience of reality.

Fourth-order simulacrum

Since outlining the three orders of simulacrum, Baudrillard has identified a fourth one. This doesn't necessarily mean that the third stage has been entirely superseded. According to Baudrillard, a new order of simulacra 'does not replace those discovered earlier: it simply joins their ranks, takes its place in a hypothetical series' (Baudrillard 1993b: 5). Initially likened to the fractal or virus, the fourth order is the phase of 'integral reality'. Writing in 2005, Baudrillard describes this moment as a 'kind of ultra reality that puts an end to both reality and to illusion' (Baudrillard 2005e: 2). In this – our current – phase, the image is so far removed from its original function that it can't

even operate as an image any more. Baudrillard has noticed that our present culture is caught up with, if not fixated on, making everything visible, transparent, knowable and immediately accessible. Think of live news feeds, interactive art, gene maps, virtual worlds like *Second Life*, surveillance technologies, digital communications and the like. They are immediate, immersive and immanent, making us enter into the image. We are so close, claims Baudrillard, that there isn't any critical distance from which to exist outside these omnipresent technologies and signs. Because of this 'immersion in the visual', Baudrillard believes that we can't talk about representations as though they are a reflection of, or response to, the world (Baudrillard 2001: 45). They are the world.

Baudrillard has spoken about the photographs taken at Iraq's Abu Ghraib prison in the context of the fourth-order simulacrum, and I believe that they are a good example to introduce you briefly to this concept. I say 'briefly' because Chapter 4 is devoted entirely to the notion of 'integral reality' as it is played out across television, computer and movie screens. In that chapter you will find a number of additional visual cases to guide your thinking. But for the moment let's return to the photos that appeared in the press in 2004 depicting American solders inflicting torture and humiliation on Iraqi detainees. In one, a man lies on the floor, his body partly out of the frame so that we can see his naked torso and a leash tied around his neck. Also in the picture is a female soldier, standing upright and glancing down at the detainee tied to the other end of the leash she is holding in her left hand (Figure 3). Another photograph shows a group of naked men tied to each other and left writhing on a walkway floor. Fellow detainees watch the exposed prisoners from their cell doors while three soldiers stand hunched over the bundle of flesh. One reaches down and appears to be grabbing at their faces or heads. There are many more like these, displaying a mixture of prisoners in degrading poses – sometimes dead – and American soldiers who are often caught grinning and giving the thumbs-up sign. In

many instances, the torturers and the tortured appear in the same photograph.

While, like most of us who saw these images, Baudrillard finds them humiliating and grotesque, he also senses that there is something banal about them. Don't think Baudrillard is being dismissive or glib here – quite the opposite. The way that Baudrillard sees it, the relentless circulation of these images across the media takes the atrocities of war into another realm – images don't portray the war, they are immersed in it or 'definitively integrated into the war' (Baudrillard 2005f: 207). This means that these photographs can't be understood as a form of documentary evidence of America's treatment of Iraqi detainees.

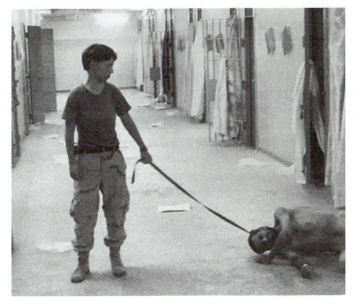

3. US soldier Lynndie England with prisoner, photo taken at Abu Ghraib prison, Baghdad.

Baudrillard claims that it is irrelevant to question whether these images are 'true' or 'false' depictions because they don't 'depict' the war but are embedded in the war strategy, offering a simulation of American power through the humiliation of the other. In all their hypervisibility of previously unseen acts of war, they

> become a parody of violence, a parody of the war itself, pornography becoming the ultimate form of the abjection of war which is unable to be simply war, to be simply about killing, and instead turns itself into a grotesque infantile reality-show, in a desperate simulacrum of power. (Baudrillard 2005f: 206)

It is interesting that Baudrillard likens these photographs to pornography as well as to reality TV. In his mind, they share certain characteristics typical of the fourth order. These types of images make everything visible. All the events and acts they portray appear to be displayed without distinction, whether it be a reality TV contestant sunbathing or a soldier torturing the enemy. Anything and everything is on view. Nothing is hidden. This drive to reveal everything, to get to some sort of truth or deeper knowledge via the image isn't always a good thing. For Baudrillard, this equates to a kind of exploitation of the image. Where once the image was 'an abstraction of the world in two dimensions' (Zurbrugg 1997: 9), nowadays images are increasingly virtualised – used for the purposes of information, communication, promotion or documentation. And in our attempts to force meaning onto the image – to oversignify it to the point where all that is rendered apparent is its total lack of distinction from anything else – we violate it, says Baudrillard. In a way, this hijacking of the image for the purposes of bolstering reality means that the image loses its autonomy as an object that can function in another dimension, outside 'real-time'. In Baudrillard's words,

> we are forced to accede to this proliferation of images, to the world's becoming-image through the screens, the universe's

becoming-image, the conversion of everything into images. But where everything is image, there is no image any more. (Baudrillard 2001: 67)

It seems that things have changed. Once images reminded us that there was something else out there. They played a role in inciting us to speculate about reality, wonder over illusion and contemplate the world in a different light. There was an encounter to be had between representation and reality, as well as the viewer and the image, which allowed a certain degree of space for reflection and for awe. Baudrillard talks about this shift in the following way:

I believe images affect us immediately, well ahead of, at an infra-level to representation, at least at the level of intuition, or perception. In that sense, an image is always absolutely surprising. Or at least it should be. Sadly, because of that, we can say that images are scarce. The force of images, most of the time, is cut off, deflected, intercepted by everything we want them to say for us. (Baudrillard 2005c: 13)

If, as Baudrillard claims, illusion plays with reality, then the production of reality in the form of simulacra divests the image of its power of illusion. What we are left with, says Baudrillard, is an ultra reality, an extreme form of reality that is all-encompassing and immediate, that predetermines our responses to images and events and kills off any element of surprise or originality that the image might once have had. We have reached a point of 'impossible exchange' when our encounters with images occur within the terms set up by today's digitised, media-saturated conditions – conditions that strive to suppress uncertainly and unpredictability (Baudrillard 2005c: 33).

The enchanted simulation

In the context of a simulated reality where everything has already been mapped out and the world is made apparent to us

instantaneously, how do we explain the appeal certain images still hold for us? Paul Hegarty suggests that 'Seduction is the term that allows Baudrillard to account for the world of appearances, and its fascination for us' (Hegarty 2004: 68). Seduction is not something that can be represented, but is best understood as a force that has the power to produce illusions. Baudrillard writes about it in the following way:

Seduction does not consist of a simple appearance, or a pure absence, but the eclipse of a presence. Its sole strategy is to be-there/not-there, and thereby produce a sort of flickering, a hypnotic mechanism that crystallises attention outside all concern with meaning. (Baudrillard 1990b: 85)

With its focus on playing with appearances, seduction is counter to simulation, which, as demonstrated in the orders outlined above, has the power to produce reality, and does so excessively in its attempt to make everything visible and knowable. The way that Baudrillard explains the illusionary force of seduction is by using the example of the *trompe l'oeil* – literally 'a trick of the eye', or in visual-arts terms a painting technique that generates the perception of three dimensionality in a two-dimensional image such as a mural, fresco or canvas. What Baudrillard sees when he looks at a *trompe l'oeil* painting is objects that jump out of the flat surface, causing a 'forward decentering effect' that goes against the deep perspectival space typical of Renaissance art (Baudrillard 1990b: 63). If we take American painter John Haberle's *A Bachelor's Drawer* (1890–4), for example, with its meticulous oil renderings of a random assortment of objects (coins, a comb, stamps, playing cards, a pipe) lying on a wooden desktop, Baudrillard would argue that unlike Renaissance perspective, which creates a harmonious and ordered rendering of reality, the *trompe l'oeil* is far more intriguing.

Baudrillard senses an element of the surreal in the way that these objects are projected forward, rather than into, the picture. By going beyond the two-dimensional space of the image, the

objects of Haberle's drawer attack our sense of reality. There is something charming yet odd about the exactness of the objects displayed. They are so perfectly like reality that they seem to be entirely 'unreal' at the same time. This, coupled with the perception that the objects on the desk come out at us suddenly, has the effect of making us wonder about the 'world's apparent factuality' or what might be beyond it. It is the sense of wonder generated by the *trompe l'oeil* that makes it an 'enchanted simulation'. It is in this respect that seduction is that which is other to simulation, those elements of enchantment and mystification associated with illusion. Unlike simulation, which abolishes the real, seduction is a challenge to the real, an attempt to counter the pervasiveness of reality. We could say that seduction recovers illusion by challenging the production of truth via the image:

The *trompe l'oeil* does not seek to confuse itself with the real. Consciously produced by means of play and artifice, it presents itself as a simulacrum. By mimicking the third dimension, it questions the reality of this dimension, and by mimicking and exceeding the effects of the real, it radically questions the reality principle. (Baudrillard 1990b: 63)

Baudrillard's words remind us that seduction is not something that is 'outside' our simulated world. On the contrary, it cannot be excluded ultimately, no matter how much the logic of simulation may dictate this exclusion. Illusion is a necessary part of constructing a sense of reality, or the world 'as is'. So the loss of illusion is an unfathomable prospect because we need it to be able to conceptualise and speak about our reality. It makes reality 'real' to us. But what we consider to be 'real' is just another form of illusion, albeit a 'vital illusion' that Baudrillard says is critical for a functioning society. What we need to be mindful of here is that the challenge to the real posed by seduction and illusion comes from within the same significatory system.

Though one has to wonder how these ideas stack up in the context of integral reality, especially given that *Seduction* was published way back in 1979. For example, how might we determine whether an 'enchanted simulation' has become 'disenchanted' or is even possible in a period of integral reality? However, it would be fair to say that as the world changes, so does Baudrillard's thought. Accordingly, he has progressively advanced his thinking about the role of these forces deemed 'other than simulation', like seduction, the fatal, evil, illusion and impossible exchange. Across his writing he has continued to seek out singular forms – those images, events and acts that confound or undo the significatory system, and which disturb the orders of truth and reality. Photography, in particular, has emerged as a site where Baudrillard probes the extent to which systems of meaning and understanding are pushed beyond their limits. We will get to photography in the next chapter.

Having now considered these alternative forces in the context of simulation, and equipped with our overview of the different phases in the development of the image as it is understood by Baudrillard, we are in a good position to look at some more of his key concepts as they relate to the world of visual culture. In the following chapters, I want to develop our understanding of images in Baudrillard's terms. By looking at the realms of art (Chapter 2), fashion and advertising (Chapter 3), film, television and virtual reality (Chapter 4), I will continue to demonstrate the applicability of his theories for analysing visual phenomena.

Chapter 2

Art

Introduction

A few years back, it was reported that a German tourist was caught spraying graffiti on an ancient glacier formation in the remote South West of New Zealand. In the midst of the Aotearoan wilderness, he sought to replicate a piece of the urban jungle. He was caught, unsurprisingly, on camera by nearby tourists and subsequently required to remove the offending material (*Stuff* 2008). Immediately the act was dubbed 'glacier graffiti' by *Trend Hunter* magazine, which likes to identify and anticipate the next big thing. It is the kind of exposure any contemporary New Zealand artist would kill for. As to what the German's motives were, I can't say. Nor can I ascertain whether this occurrence was an act of creative expression or one of vandalism, although in New Zealand this has been a point of national debate – fuelled by the death of a young tagger around the same time. That unfortunate boy was killed by the man whose fence he scrawled on (Ruscoe 2008).

Within a few days of the glacier incident, I came across a podcast on the *New York Times* website showcasing graffiti in Berlin. Apparently, the German capital is considered a haven for graffiti writers from all across Europe, and boasts a wide range of different styles and schools. Given Berlin's established graffiti culture, perhaps our Teutonic tourist was expecting a kinder reception as he honed his skills on New Zealand shores. Is there any significance to these seemingly unconnected events? As much as these incidents reveal the convergence and connection between

things in an increasingly globalised world, they also raise questions about the nature of art and its circulation and effects.

In the previous chapter we highlighted the importance of Baudrillard's notion of simulation to understanding the current operation of signs and images in a media-saturated environment. Through the process of sequentially and systematically charting the four orders of simulacra – from Renaissance times to the digital era – it becomes apparent that our current 'transaesthetic' state is one in which the privileged relationship between signs and reality has been irrevocably severed. We are, as Baudrillard says, at 'the end of a system of representation' (Baudrillard 2005a: 51). If it is no longer possible or relevant to speak about the circulation and operation of images in terms of what they represent, then where does this leave art? In an era when anything can be labelled 'art' – even spray-paint on a remote glacier – how is the perception of art as a distinguishable and unique practice sustained?

Such questions have preoccupied Baudrillard, who has written about art specifically in his study of signs and images. Most notable is his book *The Conspiracy of Art* (2005a) – a collection of his thoughts on the topic drawn largely from writings and interviews undertaken throughout the nineties and onwards. These pronouncements form the basis for many of the ideas developed in this chapter. For Baudrillard, it is necessary to single out art for special analysis – over and above other types of representation – because it constructs itself as having a unique aesthetic sensibility, in that 'it claims to escape banality the most and that it has the monopoly on a certain sublime, on transcendent value' (Baudrillard 2005a: 61–2). It must be stressed, though, that the exclusivity of art is not something Baudrillard wishes to preserve. On the contrary, he is vehemently opposed to art's claim to exceptional status above other kinds of images that circulate in mass culture, and it is this assertion that forms the basis of his criticism. Speaking on the subject, he says, 'I really

object to that. I say that you should be able to apply the same critique to art as to everything else' (Baudrillard 2005a: 62). The way Baudrillard figures it, art is no more special than other visual forms like advertising, music videos or TV programmes. Moreover, he is critical of the fact that contemporary art recycles motifs from these spheres and from past art movements. Even if, as he insists, all images are equivalent in an era of hyperreality, he has been drawn to the question of art in order to understand how it maintains its distinct status amidst a cacophony of visual signs.

The purpose of this chapter, then, is to consider critically Baudrillard's take on art and the operations of the art world. I do this by identifying and assessing what Baudrillard has written about the role and function of art, and by gauging the significance of his ideas for art practitioners, students, consumers and critics. In order to achieve this I focus in the main on three contemporary British artists – Tracey Emin, Merlin Carpenter and Banksy – whose work effectively illustrates Baudrillard's radical notion that art is 'null', and offer examples through which to demonstrate the process whereby art functions as a 'conspiracy'. As has already been established, Baudrillard's status as a key commentator on the postmodern condition – especially his theory of simulation – has had a profound impact on how we come to conceptualise and engage with images, including art. My intention here is to reflect on the value of Baudrillard's commentary on art to our understanding of visual culture more broadly. I argue that he forces us to re-examine accepted ways of understanding images, and in the process raises new questions about the extent to which we can speak about representation and reality as unproblematic terms.

Baudrillard's early writings

It is in Baudrillard's discussions of consumer society that we can find some of his earliest commentary on art. As a way of

illustrating his argument for the increasing commodification of culture, Baudrillard discusses the pop-art movement – citing Jasper Johns, Robert Rauschenberg and Andy Warhol – which he considers emblematic of the commercialisation of culture (Baudrillard 1998: 115–17). If signs are the language through which we make sense of the world, then in order for culture to mean anything, it also must become part of a system of signs and derive its meaning relative to all other signs. While art was once conceived of as distinct from the practices and processes of consumption, pop art problematises this divide, as is evidenced in Warhol's *Campbell's Soup Cans* discussed in the previous chapter. In this artwork, the techniques of mass-production, seriality and the imitation of commercial brand names and food products erode the line between the 'authenticity' of high culture (art) and 'fakeness' of low or mass culture (consumer objects). In effect, pop art renders art interchangeable with any other commodity sign. It is no longer rare or unique. Writing in *The Consumer Society* Baudrillard states: 'As "mass-produced" object, works so produced become effectively objects of the same kind "as the pair of stockings and the garden chair", and acquire their meaning in relation to those things' (Baudrillard 1998: 107). As a result, art's assumed privileged position as a mode of representation that can reveal a greater truth or meaning about the world is diminished.

Curiously, Baudrillard singles out the artwork of Andy Warhol and Marcel Duchamp for praise, despite being disparaging of art more generally. He is especially critical of the artists dubbed simulationists who emerged in New York in the 1980s and whose work he sees as failing to offer any sort of insight into the operations of simulation. By treating simulation as something that could be represented, the art world, according to Baudrillard, completely missed the point about simulation. In contrast, Baudrillard champions Warhol for reducing art to the status of a non-signifying image. His early works astutely demonstrate

the commodification and massification of culture though its industrial modes of production and homogenised, serial depiction of consumer objects. The contemporary art preceding this moment (even Warhol's own *Brillo Boxes*, which he repeated in the 1980s) fails to offer such a critique because it can only operate as arch parody – a simulation of the blank parody captured by Warhol's initial silkscreen prints of commercial products. For this reason contemporary art is devoid of the 'child-like curiosity, a naïve enchantment of discovery' that Baudrillard associates with pop art (Baudrillard 1998: 120).

Likewise, Duchamp is celebrated as truly avant-garde by Baudrillard because his readymades marked the turning point away from traditional art aesthetics. By putting a urinal in a gallery (the artwork known as *Fountain*), Duchamp questioned the category of art and its associated aesthetic value. More to the point, it is the playful irony of this gesture that resonates with Baudrillard. By locating the urinal – an object that is so far removed from established notions of art – in the place it is least expected to be, Duchamp invests it with a different meaning. That is, the urinal is no longer a functional object but has become an aesthetic object. What's more, the viewer is provoked to take up the challenge put forth by Duchamp to think about art differently. By inciting us to consider a urinal as art he 'set in motion a process in which everyone is now implicated', whereby mass culture is made into art and vice versa (Baudrillard 2005a: 62). However, in today's art climate there would be nothing shocking about this act. The visceral, the everyday and the ugly are the mainstay of galleries everywhere – indeed, it is what art lovers expect to see. Even toilets have become part of the canon, with a gallery devoted entirely to sanitary devices in Stoke-on-Trent, England. The role of such cultural institutions has not gone unnoticed by Baudrillard, who has written about Paris's Pompidou Centre (or Beaubourg) as a symbol of culture being made into a spectacle.

In his book *For a Critique of the Political Economy of the Sign* (1981), Baudrillard continues to show an interest in art through his study of the art market and the modernist preoccupation with authenticity, as embodied by the signature of the artist. In the modern consumer society, economic exchange is attached to sign exchange so that the function of the material object is of less importance in determining its value than the relation between signs. Baudrillard argues that in the art economy, what is being purchased or consumed at an auction is no longer an art object whose originality correlates with its exchange value. While it used to be the case that the signature of the artist acted as a marker of authenticity and a means to gauge the value of an artwork, Baudrillard suggests that this no longer holds. Rather than value being anchored in some way to the quality of the work (demonstrated by the signature), it has become liberated into a pure circulation of signs where the escalation of bidding appears to be reliant simply on the value accruing through the very auction process. This shift away from the artist's signature and authenticity of the painting marks an important moment in the changing status of art and its relationship to the world. When a painting's worth is determined by the frenzied process of the bidding war, we cease to approach artwork in terms of its symbolic function (whereby the ritual process of exchanging an object is what gives it worth) or in terms of its pedigree (or who signed it and who owns it). Rather, an artwork like Warhol's 1963 *Liz*, which was sold by Hugh Grant, comes to be understood as a sign that proclaims its own exchange value in the market.

In noting the operations of sign exchange in mass-media culture, Baudrillard is not only advancing a theory of consumer society but one of art. In his musings on art, many of the points he makes about commodification, mechanical reproduction, authenticity and the collapse of distinct aesthetic spheres are consolidated in his explorations of second- and third-order simulacra. These ideas, which Baudrillard developed throughout

the 1970s and 1980s shape the subsequent formation of concepts put forth in *The Conspiracy of Art*. Because these aspects of his *oeuvre* have been discussed at length in Chapter 1 of this book, I do not revisit these debates here, but note them to advance the position that the visual arts have informed the development of Baudrillard's thinking. Moreover, it is important to stress them again in order to grasp the significance of sign exchange to changing cultural conceptions of 'reality' and 'representation', which I think is the key to understanding Baudrillard's approach to art.

During the process of writing about art and representation Baudrillard took up photography, which suggests that his theoretical interest in art may be fuelled by his own practice. Although this presumption has been disputed by Baudrillard himself, who does not relate his writing on the subject with his interest in taking photos. Despite the theoretical influence of artists like Warhol to the development of his thoughts about signs and consumption, Baudrillard frustratingly does not undertake any in-depth analysis of particular artists or offer a robust study of certain art movements. Art seems to serve the purpose of advancing his broader claims about the operations of signs and culture, rather than existing as a site of sustained analysis in its own right. Even though he cites Warhol and Duchamp to explore the differences between pre- and postmodern art (Baudrillard 1996a: 75–84), compares the paintings of Edward Hopper to the light qualities of the photograph (Baudrillard 2000), and makes fleeting references to the paintings of Mark Rothko (Baudrillard 1994a: 210), his studies are limited because Baudrillard does not care to survey the artistic output of these artists in any depth nor offer any substantial critical analysis of their biographical trajectories. Nor does he differentiate between various artforms when mounting his critique. Video, sculpture, painting, new media and performance art are all under attack. He does, however, display a notable interest in the medium of photography, with respect

to his own photographic aspirations as well as his writings on the object, disappearance and illusion. His engagements with this mode of creative practice do not seek to evaluate photography as a visual or artistic medium. Instead his explorations of the photograph are preoccupied with its power to make objects and subjects appear and disappear, rather than any role photography might play in capturing the world on film. And while I criticise Baudrillard for not paying enough attention to actual art, he does offer a considerable assessment of the work of Sophie Calle in his writing on photography, which he approaches as a mode of seduction. Given Baudrillard's fascination with photography over and above other types of cultural production, these ideas will be revisited and developed more fully later in this chapter under a separate section on photography.

Baudrillard and art theory

It is useful at this point to ask, just as Nicholas Zurbrugg – editor of *Jean Baudrillard: Art and artefact* – does, 'Just what is it that makes Baudrillard's ideas so different, so appealing?' (Zurbrugg 1997: 1). Those familiar with English pop art would instantly recognise that Zurbrugg's question references the 1956 artwork by Richard Hamilton titled *Just What is it that Makes Today's Homes so Different, so Appealing?* The association Zurbrugg makes between Hamilton and Baudrillard is an apt one, given the tendency towards play and irony in both Hamilton's paintings and Baudrillard's writing, no doubt influenced by a shared appreciation of Marcel Duchamp. Even though Baudrillard is for the most part disapproving of the art scene, and is not an art theoretician *per se*, his ideas have nonetheless engaged artists and art commentators. In answering the question he sets out, Zurbrugg concludes that what makes Baudrillard's ideas so different and appealing comes from 'suggesting alternative ways of thinking about things in general, and elaborating specific ways of reconsidering both past culture and those ongoing cultural

practices stretching from the present to the future' (Zurbrugg 1997: 2). This alternative and innovative way of thinking that Zurbrugg identifies is exemplified in Baudrillard's approach to art, which is quite different to the usual practices of art criticism and theory.

Conventional writing on art can be generally understood to be an interpretive exercise. It is preoccupied with questions like: how do we 'read' art? judge art? appreciate art? How important is the artist to how we value and understand an artwork? Who looks at art, and how does this shape or influence the meanings we derive from it? Qualities intrinsic to the work (form and compositional aspects) along with those factors external to the work (modes of production and cultural reception) are commonly scrutinised to make sense of the art object.

Operating along these lines is feminist art criticism, which is a popular mode of visual analysis commonly taught in art-history, visual-culture and film-studies classrooms. Via an examination of the socio-historical context in which art is produced and consumed, it approaches images as carriers of meaning that can tell us about the construction and maintenance of gender categories (Bal 1996). It offers a particular interpretation or 'reading' of an image to reveal the broader operation of gender and other power relations in society. One such example of this type of analysis is Lynn Nead's study of Victorian high art. She examines the triptych *Woman's Mission* (1863) by George Elgar Hicks, which depicts three scenes in which a woman enacts her role as mother, wife and daughter. Nead argues that the painting constructs a feminine ideal that is associated with domesticity and reinforces norms of femininity based on dependency, subordination and virtue:

The three images show the *same* woman with three different men – her son, her husband and her father. In other words, she is defined through her relationships to these men. Furthermore, whilst the woman is fixed in all three images at the same stage in her life – an

optimum age when she can fulfil all three roles of young mother, dutiful wife and caring daughter – man is shown to mature and age. It is *his* life-cycle from childhood to old age which structure the narrative of the triptych and which defines woman's domestic roles and duties. Through *both* form *and* content *Woman's Mission* offered the Royal Academy viewer a realistic image of Victorian domestic life. (Nead 1987: 79)

In deciphering the form and content of these images, Nead puts forth an interrogation of gender power relations. In the tradition of feminist art criticism, she analyses what is depicted in representations and evaluates the social structures, cultural practices, ideological and discursive systems by which gender bias operates. Commonly this analysis relies on semiotic and psychoanalytic techniques, which involve unmasking the 'deep' or hidden meanings in a text, as expressed through signs and motifs as well as considering how audiences might construe these messages (Pollock 1988). Interpreting art from a feminist perspective, however, involves more than analysing how women are represented, necessitating a broader examination of how the feminine is valued across the spectrum of art, as well as the issue of women's agency – as artists, critics, patrons and viewers (Broude and Garrard 2005).

In contrast to such interpretive approaches, Baudrillard is not concerned with determining good art from bad, or making any type of judgement about the value or impact that art might have – be it aesthetic, economic, political or social. In his own words, 'I am in no position to say, "this one is bad, this one isn't"' (Baudrillard 2005a: 62). Nor does he think there is any 'meaning' or 'truth' behind the image to be uncovered:

Images are no longer the mirror of reality, they have invested the heart of reality and transformed it into hyperreality where, from screen to screen, the only aim of the image is the image. The image can no longer imagine the real because it is the real; it can no longer transcend reality, transfigure it or dream it, since images are

virtual reality. In virtual reality, it is as if things had swallowed their mirror. (Baudrillard 2005a: 120)

It is because of his deliberate rejection of conventional modes of art criticism that Baudrillard's pronouncements mark a notable intervention in artistic debates. Through his radical assertions he provokes the reader to reconsider assumptions that often remain unchallenged and unquestioned, namely the notion that art is a unique representational form that has intrinsic value and ideological weight. He is concerned with evaluating art

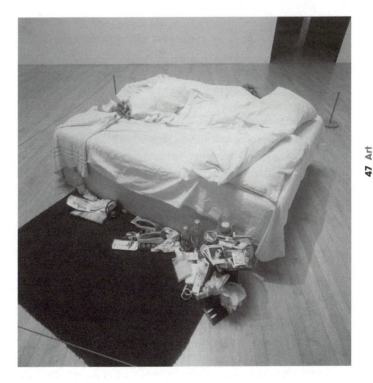

4. Tracey Emin, *My Bed* (1999).

within a particular cultural moment – an era of hyperreality – in which what was previously understood to be a system of representation has become unhinged from a coherent reality and thus meaning is subsequently established through the relations among signs. Instead of being preoccupied with revealing the meaning of an artwork, or assessing how it might be interpreted or judged, Baudrillard laments the fact that a critical logic is no longer meaningful to the task of considering art. In the process of doing so, he identifies and describes a particular tendency in the current art scene towards nullity.

Art as null

Baudrillard puts forth the claim that contemporary art strives for banality – it deliberately shuns fine art convention in favour of appropriating past styles and quoting mass culture. While Baudrillard – along with postmodern and post-structural thinkers – recognises that with the demise of grand narratives comes the awareness that 'everything is a quotation: everything is textualised in the past, everything has always already existed', he is at pains to distinguish art from other spheres where reappropriation occurs (Baudrillard 2005a: 55–6). What makes art different, he insists, is that 'It plays on the fossilised irony of a culture that no longer believes in that value...the artistic world no longer believes deeply in a destiny of art' (Baudrillard 2005a: 56). In other words, it is art's own knowledge that it only attempts to simulate itself which makes it null or banal. It can no longer strive for transcendence or convey a higher purpose.

We can see this tendency in the work of an artist like Tracey Emin, whose deliberate use of unremarkable materials and subject matter forms the basis of her art. By employing mass culture and everyday materials in the construction of *My Bed*, 1999 (Figure 4), for example, Emin rejects notions of great art and the canon of the (male) masters. The rumpled sheets and litter of personal effects at the foot of the bed reveal traces of intimacy, suggesting an

immediacy and human presence through the residue of body functions – drinking, sex, smoking. Perhaps the mattress is still warm, indented by the body that recently lay there. It shows a private space and evokes associations with the feminine, the domestic, the body, the visceral, and that which is usually hidden from public view. Some would consider her stained undies and cigarette butts objectionable. Effectively, the viewer feels uncomfortable, as though they have stumbled into the personal life of a stranger who is unaware that their secrets, habits and flaws have been revealed for all to scrutinise.

And while *My Bed* appears in some aspects to be intensely personal, it is at the same time meaningless. It could be anyone's room – the abode of the generic 'new' woman, liberated from the constraints of marital obligation and the feminine virtues of chastity and cleanliness. Although the artwork is presented as an actual bed that the artist slept in, the artwork could have been compiled from a random assortment of items that have no connection to a real person out there, but have been collected and displayed to construct a scene that we presume to be an authentic and intimate snapshot from life. The process of putting such a private scene on display encourages the viewer to contemplate the erosion of the public/private divide in an age of transparency, confessional culture and media intrusion.

Yet if we are to follow Baudrillard's logic, there is nothing profound about this artwork. Indeed, it is the very fact that it proclaims through its subject matter and composition that it is nothing special, that it is banal and boring, that it is simply everyday life, which illustrates his claim that today's art strives for nullness. As Sylvère Lotringer (Lotringer 2005) points out, in stating that art is null Baudrillard is not making an aesthetic judgement inasmuch as he is observing a certain condition whereby 'art is no different any more from anything else' (Baudrillard 2005a: 18). By fostering the erosion between high and mass culture, art becomes part of, rather than existing

outside, the vernacular. It makes itself meaningless by being like everything else. By making *everything* visible – rumpled tights, tampons, empty liquor bottles – Emin's artwork is null because that which was once private and confidential becomes hypervisible and over-exposed. Art recycles itself by incorporating unwanted waste and residue in the same way that it recycles the 'look' and creative methods from the past. By existing in a referential dance with signs and symbols from everyday life, as well as with prior art movements, contemporary art nullifies itself by surrendering any power it might have had as aesthetically unique. By the same token, Emin's art itself has become over-exposed, it circulates beyond the gallery walls and into the mainstream via style mags, celebrity gossip rags, TV programmes and fashion bibles. By proclaiming itself as everywhere, it ceases to be locatable anywhere. By 'confiscating banality, waste and mediocrity as values and ideologies' it screams, '"I am null! I am null!" – *and it truly is null*' (Baudrillard 2005a: 27).

Whereas once art served to push the boundaries of expected social values and aesthetic conventions, Baudrillard argues that the avant-garde tendencies observable in modern art movements like Surrealism have been superseded by 'regressive utopias'. He considers today's art to be preoccupied with earlier styles and ideas, stating that

art is going through a sort of travelling shot of its own history, a more or less authentic or artificial resurrection of all its past forms. It can surf through its history and rework it, not exactly by exploring new fields – after all, maybe the aesthetic world is finite like the physical universe – but by veering along the final and necessary curve of things. (Baudrillard 2005a: 50)

Certainly Emin's bed can be scrutinised this way – as alluding to Duchamp's readymade through which the everyday and unextraordinary becomes art because it is located within the gallery confines. Once shocking and subversive, the readymade

has become a commonplace technique in the art scene. *My Bed* can also be related to the canon of feminist art practice through its autobiographical elements and use of objects on which traces of the gendered body can be found.

The work of English artist Merlin Carpenter offers another site through which to assess contemporary art's propensity to resurrect past forms. Shown in the main hall of Vienna's Secession gallery, his exhibition *As a Painter I Call Myself the Estate of* (2000) is primarily made of up a series of paintings that allude to familiar aspects of visual culture, such as fashion photography. In preference to replicating in-vogue images in all their glossy perfection, the female models he depicts are composed of visible brushstrokes and drips, and are located against painterly, expressive backgrounds that often contain other references to mass culture, such as cars. While derivative of the photographic spreads of fashion magazines, the artist aims to re-create these images so that they look intentionally inept. Another way that he hints at the past is through his painting style, which is reminiscent of the work of figurative painters of the 1980s like Julian Schnabel. Placing a full-size speedboat in the gallery space, in among the paintings, also demonstrates a preoccupation with art movements like pop, which used the images and techniques of mass-production to destabilise the distinctions between art object and consumer product.

In these various ways, Carpenter exemplifies Baudrillard's claim that 'All the movement in painting has been displaced towards the past. Employing quotation, simulation, re-appropriation, it seems that contemporary art is about to reappropriate all forms or works of the past, near or far – or even contemporary forms – in a more or less ludic or kitsch fashion' (Baudrillard 1997b: 7). It is through the artist's deliberate and knowing play on art convention that art is lost. It can only ever exist as a simulation when caught in a reflective game with the signs and symbols of today's world of film, advertising and

pop culture. It is at this point that art nullifies itself. It can no longer ever be original.

As the following interview between the artist and Isabelle Graw demonstrates, Carpenter is keenly aware of the operations of art, and in the form and subject matter of his paintings he seeks to resist the possibility of meaning in his work, or, to paraphrase Baudrillard, he strives for nullity.

IG: Looking at the paintings there are a lot of hints that point out the fact that you shouldn't think about them in terms of representation of women. For instance there is a painting like that in the first space as you enter where you see a man and a woman and the woman looks like Kate Moss. The woman's skirt is obviously a zone for painting and the first wall as well looks like a display of different painted possibilities. I think that the paintings themselves make clear that it doesn't make sense to speak about the fact that women are represented. But on the other hand you do use these images. I think you talked about that at another time when your show at Nagel was presented that you like to use these images that are totally overdetermined like images of women and I would say images of cars as well. It's not totally random and I think it's quite systematic and very consistent. You hardly find in the main room a painting where no car can be detected and at some point you want to see one. Maybe we can talk about why you have such an interest in those overdetermined motifs.

MC: I'm trying to get away from the idea of producing a meaningful image. You'd have to use something that's sort of a cliché because that is the only way you can make an image mean nothing if it's already known. It's a very difficult question; I think it's almost unanswerable.

IG: Maybe it's unconscious.

MC: Well no, I wouldn't say so, but it becomes the way you work. Some of the images, some of the source material I use is incredibly mediated, it's not just fashion magazines, it's from 1984. I'm thinking more about that it's from 1984 than what it is as a picture. It relates to how magazines are and how fashion photos are now and how they've become increasingly eroticised and that process has accelerated and that has become a cliché. I find this kind of

work, fashion photography and also the other associated fields involved like the art direction and make-up and the magazine itself, actually quite interesting. I mean I'm interested in the magazines as the product not whether it's a girl in a jungle or whatever. I don't know if cars are mediated in quite the same way, they certainly have a look and it's about that look.

IG: But always cars and girls, I mean a lot of car advertisements use girls for instance.

MC: I don't think my paintings look like car – or any kind of – advertisements. They look like paintings really. Talking about things like mediated overdetermined images, paintings are mediated in exactly the same way as cars. They are as stupid and as mediated as cars. Especially an abstract painting is the same type of cliché.

IG: Maybe these kinds of highly overdetermined and highly mediatised images are a good way to achieve the effect that you called emptiness or flatness.

MC: Yes but that's an obvious point. It's hard to say what is interesting about that; it sounds a bit boring. I have an interest in eighties approaches to art: in making a big object, filling it with empty signification and seeing what happens. But at this point in time it's a quote about the eighties, it's not the eighties themselves. So I think doing that has a different kind of meaning to what it would have had then, but I'm not totally sure what that is. I know that it's about the context now, it's trying to use some of the embarrassment and extreme sort of weird freedom of some mid-eighties art, between painting and neo-geo, that kind of that period. Which was a period I liked in a way but it's not that I'm trying to recreate it. I think the situation is so different now that you could do it again. It's an exploded field now, you'd be doing that in an exploded art context, and then to do it again would be a different kind of project, a more open, experimental project and maybe even more experimental than then. (Graw and Carpenter: 2000)

I have cited the interview at length here because it typifies the state of affairs that Baudrillard is describing. The awareness that Carpenter exhibits about the operations of the sign while debating the impossibility of finding meaning in his artwork is

the very kind of discourse that Baudrillard insists erases the art object. Art is made null through the proclamation of its nullity by the artists themselves, who, as in this instance, reject the attempts made to interpret their paintings. Moreover, it occurs through the shared awareness of art's circulation as a commodity, much like the mass-produced cars and fashion spreads that Carpenter references in his paintings.

Another sign that art is null is the calculated use of 'overdetermined imagery' – motifs that are so prevalent in culture that they become emptied of meaning. Baudrillard insists that contemporary art is forever sentenced to banality because it can only ever circulate relative to other signs. As a result, art cannot signify anything because 'Its only reality is its operation in real time and its confusion with this reality' (Baudrillard 2005a: 89). It is this knowledge about the operations of art that kills any possibility of mystery or aura, and which leads Baudrillard to lament whether art can ever again be avant-garde.

As suggested by the analysis offered here, contemporary art practice has moved beyond Clement Greenberg's observation that avant-garde artists problematise 'high' or established cultural traditions, as well as showing disdain for mass cultural products (Greenberg 1939/1961). Now, as is evident in the work of Carpenter and many others, it is commonplace for art to embrace mass culture (with respect to both subject matter and modes of production) as well as traditional formal structure and subject matter, often while employing appropriation, irony, parody and the like. So, if the tendency of art after modernism is consciously to appropriate and recycle elements from already-existing visual artefacts, as Baudrillard and others have pointed out (Buchloh 2000; Burger 1984), what we end up with is art that ceases to operate as avant-garde, truly original, forward-looking and counter to mainstream practices, values and beliefs.

But Baudrillard sees no problem with this *per se*. After all, as has been discussed at length in Chapter 1, qualities like

uniqueness and originality become complicated in an era of simulation where the distinctions between mainstream and marginal, high and low, and reality and representation no longer hold. What Baudrillard does take issue with, however, is the necessity to maintain a perception of artistic endeavours as avant-garde. In others words, despite the self-conscious artistic turn towards appropriation, simulation and recycling, we continue to uphold the notion of art as exclusive and distinct from other visual forms. This is manifest in the way we speak about, respond to and perceive art, as made apparent in the interview cited above. There is a duality at play here. By insisting on the meaninglessness of his art in an era of 'empty signification', as Carpenter does in the face of the interviewer's attempts to make sense of his motifs, we see an example of art striving to be null. At the same time this very banality is celebrated, elevated, made important. This is despite the fact that the hierarchies of value that once allowed us to define art as distinct from other modes of representation are under attack, as both the artist and interviewer are well aware. Ultimately, what Baudrillard is describing here relies on a conspiracy in which we are all invested.

The conspiracy of art

Even though contemporary art has reached a point where it can only simulate itself, we don't seem to be experiencing a subsequent eradication, or death, of the category 'art'. Surprisingly, the nullity of art appears to have produced the opposite effect. In a paradoxical way, the more art becomes indistinguishable from everything else, the more of it there seems to be. Art is everywhere, and just about anything can be labelled art. This can be explained by the way we cling on more tightly to the idea of art when it becomes difficult to determine what is art and what isn't. We fear losing the category art, even if we cannot definitively know what defines or constitutes its parameters. The 'we' being referred

to here are artists and viewers, who Baudrillard identifies as key players in the conspiracy of art:

There is a shameful complicity shared by creators and consumers in a silent communion as they consider strange, inexplicable objects that only refer to themselves and to the idea of art. The real conspiracy, however, lies in art's complicity with itself, its collusion with reality...(Baudrillard 2005a: 89)

These 'creators and consumers' simulate their roles, playing these parts in a way that surpasses mere imitation. They appropriate how artists and consumers act so closely and consistently that it becomes our reality of how art is made and looked at. Consuming art involves the ritualistic standing in front of an artwork and nodding appreciatively, even if one has no idea what it is. Viewers are co-conspirators in the game of art, who know the rules and are keen to play. Although the act of looking is supposed to elicit enjoyment (or, indeed, non-enjoyment), the nature of the aesthetic response doesn't really matter in the bigger scheme of things, as it is of less importance than the process of acting out the part of an art appreciator. For the artist the same logic applies. Baudrillard has explained the role of the artist in this way:

Even the 'creative' act replicates itself to become nothing more than the sign of its own operation – the true subject of a painter is no longer what he or she paints but the very fact that he or she paints. The painter paints the fact that he or she paints. In that way, at least, the idea of art is saved. (Baudrillard 2005a: 91)

And of the viewer's part in the art conspiracy, he says,

The viewer literally consumes the fact that he or she does not understand it and that it has no necessity to it other than the cultural imperative of belonging to the integrated circuit of culture...the consumer moves through it all to text his or her non-enjoyment of the works. (Baudrillard 2005a: 91)

Along with these co-conspirators who help sustain the idea of art, the conspiracy that Baudrillard identifies relies on the 'reality principle': the situation where art becomes an effect of its disappearance. In previous writings he has explained this phenomenon using the example of Disneyland. Baudrillard argues that in the era of hyperreality, it is impossible to locate the 'authentic' America, yet fantastical theme parks such as Disneyland produce our 'reality' of America by concealing the fact that there is effectively no difference between the two in an order of simulation (Baudrillard 1994b: 12). Similarly, with respect to art, Baudrillard is saying that the function of art becomes one of concealing the fact that it has so thoroughly and successfully pervaded other spheres of social life (advertising, fashion, politics etc.) that we can no longer single it out as different from any other aesthetic modality. In colluding with reality, art loses its subversive force. It simply maintains the status quo of which it is part – upholding the idea that there is a coherent category called 'reality' and a knowable entity called 'art', rather than challenging these very notions in the way that avant-garde art once did.

The more an artist like Tracey Emin produces artworks like *The Perfect Place to Grow* (2001) and *One Secret is to Save Everything* (2007), which blur the distinctions between art and other representational forms, the more critics and commentators champion the existence of these artefacts in order to hold onto a notion of art, as incoherent or elastic as that classification might be. The 1999 Turner Prize nomination for *My Bed* is one such example of this tendency. Through the process of selecting and defining 'exceptional' examples of what art should be, the prestigious competition operates to secure the uncertain category of art and distinguish it from other mass culture and visual forms. The very controversy *My Bed* elicited (as do most nominations each year) helps to uphold a semblance of art, which obscures the actuality of its disappearance. Baudrillard believes that there can be no 'true' or 'authentic' art that exists behind the hype. While

it could be argued that art prizes – like galleries proclaiming the next blockbuster exhibition, or auction houses making record prices – obscure the 'true' nature and purpose of art by drawing it into the realm of commodity culture, Baudrillard suggests that the opposite is occurring – commercial practices become the very elements that sustain art as unique, important and meaningful. Through institutions such as these, as well as the roles that the viewer and artist play, art creates its own importance to hide its nullity.

There is something ironic in the way that the art world relies on people subscribing to the idea of art while being expected to reserve aesthetic judgement or avoid making sense of an artwork in a postmodern era where the meaning of things is uncertain. The art market is symptomatic of this, given that the two modes by which art is valued in consumer society (aesthetic and economic) don't seem to mean much any more. Abstraction is revered equally with figurative art, and graffiti is appreciated as much as portraiture. And buyers are willing to pay vastly inflated prices for it. A case in point is the recent auction of stencil art by street-artist Banksy. As reported in the news, 'Over at Bonham's auction house last night the world's first sale of urban art saw a Banksy screenprint of Kate Moss, a pastiche of Andy Warhol's portrait of Marilyn Monroe, fetch three times its estimate, selling for £96,000' (Brown 2008).

Despite eschewing the high profile that comes with being an artist by hiding his identity, and even though the strategies Banksy uses in producing his art means he has largely avoided exhibiting in commercial gallery spaces (stencilling on live animals and buildings), his art had nonetheless become highly commoditised. Inflated art prices are symptomatic of art becoming an ultra-commodity. In the global art market, the cost of an artwork does not necessarily correlate with its exchange or aesthetic value, because these indicators are overtaken by the delirium of the art auction, which in itself generates value.

Like the other artists discussed in this chapter, Banksy's art is often indistinguishable from other signs and objects of mass culture. And it is this very lack of distinction between art and the world around it that gives art its 'fatal quality'. The art auction makes this apparent. Street art like Banksy's takes on more value as it becomes more visible in a circuit of signs. The graffiti and spray paint that covers the side of buildings, trains and bridges become worth more than the very objects that have been tagged. Subsequently, this raises dilemmas around the preservation of graffiti in urban spaces, as is the case in Melbourne, where debate raged over whether to conserve a Banksy stencil in a city laneway, given that 'the rocketing value of Banksy's work means it may have become more valuable than some of the gilt-framed canvases hanging in Australia's largest galleries' (Jinman 2008). Eventually it was agreed that the small stencil of a figure wrapped in a coat and wearing a diving helmet would be covered by a sheet of clear perspex, in an attempt to 'protect' the 'artwork' from vandalism. Yet this gesture appears to have acted as a beacon illuminating the status of the stencil as 'art'. Vandals poured paint behind the plastic sheeting, destroying the image. The culprits left their mark, scrawling 'Banksy woz here' over the defaced surface. The laneway remains, as ever, grimy and rat-infested.

Photography

It is through his writings on the photograph that Baudrillard might offer another dimension to analysing art, which is quite different to the critique we have looked at so far. The topic of photography features throughout his theoretical investigations, with numerous articles devoted specifically to the subject 'Please follow me' (1987), 'The art of disappearance' (1997), 'Photographies' (1999), 'L'Autre' (1999), 'Photography, or the writing of light' (2000). Consistent with his stance on art, Baudrillard avoids construing the photographic image in terms of aesthetics or socio-political

meaning. Counter to common understandings of the photograph's function, he does not believe that it captures the identity of a person or semblance of the thing depicted. 'The purpose of a photograph is not to document the event' (Baudrillard 2005e: 13), nor is it a subjective process of interpretation or expression by the photographer.

Baudrillard is careful to distinguish photography from other creative processes in order to justify the special attention he devotes to it. He claims that it is the 'instant and irreversible' nature of the photographic image, the 'obsessional, idiosyncratic, ecstatic and narcissistic quality' of photography that sets it apart from practices like painting and digital photography, where images can be endlessly manipulated (Zurbrugg 1997: 13). For Baudrillard, this distinction hinges on the unique way that the photograph inverts common understandings of the relationship between subjects and objects. Conventionally, we tend to think that it is the subject/photographer who determines what they photograph (the object). In this case, it is the subject who has the power to make the object appear through the process of taking a picture. But in Baudrillard's schema the opposite occurs – it is the object that discovers the subject. The object being photographed makes itself visible to the subject/photographer.

Photography is privileged in Baudrillard's writing because he considers it to be the one visual domain where we can witness this dual and reciprocal relationship between the subject and object. As Rex Butler has observed, 'the aim of photography is the very bringing together of subject and object that Baudrillard speaks of as the ambition of radical thought' (Butler 2005: 1). This tendency to go beyond the realm of the aesthetic towards an engagement with the object is present in Baudrillard's own photographs. While they appear at first to be realist shots of ordinary objects and scenes (a partially submerged car, a defaced wall), their content becomes secondary to the actual process, which Baudrillard likens to an 'anthropological arrangement that

establishes a relationship with objects … a glance on a fragment of the world allowing the other to come out of his or her context' (Baudrillard 2005a: 73). *Saint Beuve* (1987) shows an empty chair draped in a rich, red fabric. The creased and crumpled material implies that someone has just got out of it and Baudrillard has captured this fleeting moment in the immediate past. Little details, like the fabric slipping off the seat, are the seizing of a particular instant which can never occur again. And we'll never know who once sat there. Another, *Punto Final* (1997), shows Baudrillard's own shadow cast over a brick wall that shimmers with a yellow incandescence. The wall/object reveals Baudrillard as the photographer/subject. Or could the shadow be the trace of the subject disappearing?

His own images illustrate another key aspect of photography, one which distinguishes it from other types of representation. It is what Baudrillard refers to as the singularity of the photographic event – 'the moment in which the world or the object vanishes into the image' (Zurbrugg 1997: 30). Generally, we think that photographs can reveal some essence or truth about the object we are photographing. The photo is considered evidence that someone existed or something happened. Think of photojournalism, professional portraits or holiday snaps. Yet Baudrillard turns this assumption on its head to argue that the inverse is true. Photography does not show us reality. Instead it depicts the absence of reality – it captures only traces (the shadow, the empty chair). Or in Baudrillard's words, 'Every photographed object is simply the trace left behind by the disappearance of everything else' (Baudrillard 1997a: 28). What photography presents us with is an illusion. But in Baudrillard's radical thought this is not a bad thing, as illusion is not a false or negative attribute. On the contrary, illusion is the only thing that we can be certain is real, because it plays with reality. For these reasons, Baudrillard considers the camera to be an instrument of magic, because it secures our perception of

reality, which at the same time ensures that the object always remains a mystery.

This magic quality of photography can be seen in *Suite Vénitienne* (1979) by conceptual-cum-photographic artist Sophie Calle. This work is analysed by Baudrillard in the article 'Please follow me' (1987). Calle follows a stranger to Venice without his knowledge and takes photographs of him at every opportunity. This act of shadowing intrigues Baudrillard, because it operates in the fatal realm of seduction and the game. When Calle photographs this man,

> she steals his trace from him, she photographs him, she photographs him continuously. Here photography does not have the perverse function of the voyeur or archivist. It simply says: here, at a certain place and time, under a certain light, there was someone. Which also says, simultaneously: being here, at this place and time, had no meaning – in fact, there was no one – I who followed you, I can assure you there was no one. These are not photo-mementoes of a presence, but photos of an absence, that of the followed, that of the follower, that of their absence from each other. (Baudrillard 1987: 104)

In this respect, Baudrillard configures photography as a kind of 'automatic writing', in that it is the object being photographed that imposes its presence, rather than the photographer or subject determining the image. Moreover, it is the loss of reality – an absence – that photography captures. And it is this trace that Baudrillard considered unique to photography. In a similar way to Barthes's concept of the 'punctum', the power of the photograph is generated by our longing for a reality that we can never know. Note that Baudrillard attributes to photography a power that he argues contemporary art does not have. What moves us when we see a photo is not what is represented or visible, but the fact that the photograph can only portray absence, hence the impossibility of reality.

All of this doesn't necessarily mean that contemporary photography can avoid the label of 'null' and 'banal'. Certainly the

works of photographers like Nan Goldin and Gregory Crewdson are typical of much postmodern art practice. Crewdson's staged, cinematic scenes of suburban life resurrect past visual styles, while Goldin's unconventional portraits of urban existence display a preoccupation with the everyday and the residual. Celebrity snappers like Annie Liebowitz, David LaChapelle and Mario Testino often combine and conflate the realms of art, fashion photography and celebrity shots. I imagine that Baudrillard would find the precisely framed shots of Andreas Gursky and Tacita Dean too crafted and deliberate. Through careful composition they make the object do their bidding – their controlled approach to the photographic event kills the possibility for the object to make itself seen. Baudrillard thinks that most contemporary photography like this displays a 'forced signification', which imposes meaning. On surveying Baudrillard's writings on photography, he appears to draw distinctions between what he considers 'good' and 'bad' photography. He likes Sophie Calle, Luc Delahaye and Mike Disfarmer but is dismissive of contemporary photography on the whole – a pattern that echoes his approach to contemporary art. Yet for Baudrillard, good photography is not determined by aesthetic values, rather 'good photography does not represent anything … it captures this non-representability, the otherness of that which is foreign to itself' (Baudrillard 1993b: 151). Hence, amidst the nullity and banality of simulated realities, Baudrillard sees potential in photography. Its ability to make the object appear as a strange attractor – a secret form or mysterious project that breaks away from aesthetics, signification and meaning – allows for the possibility to invert the established order of things and challenge us to think about the world differently. Like the man who leads Sophie Calle around the streets of Venice, or the random objects that appear in Baudrillard's photos, it is those events that go beyond aesthetics, moments that are more like anthropological processes than artistic expressions, which excite Baudrillard.

Art's fate/fatality

When interviewed by Sylvère Lotringer in 2001, Baudrillard noted that

Artists always believe that I am casting judgement on their work and that I am telling them: 'This is not good.' So there is a real misunderstanding there. Art may also be null on the aesthetic level, but this is not really the problem, simply an insider's question. (Baudrillard 2005a: 78)

Certainly, Baudrillard's observations on art have been widely interpreted as statements of judgement and taste. He can also be accused of being too general in his assessment of contemporary art, because he fails actually to analyse any particular artworks, address the role of new technologies, or consider the specificities of non-Western contemporary art – much of which draws on an alternative aesthetic tradition. To see his writing this way, however, is to risk missing his unique contribution to visual theory. For those attempting to make sense of, engage with and contribute to our visual world, Baudrillard's diagnosis of the art scene offers a new dimension through which to approach art in an age of simulation and sign saturation. Avoiding the route of interpretive analyses, the thinker dubbed 'the angel of extermination' steers us towards questioning the privileged status of art in a culture that is transaestheticised. Not everyone, however, is seduced by his ideas. Timothy Luke warns that 'if one accepts Baudrillard's pronouncements, there is little that can be said for or about art' (Luke 1994: 224). Douglas Kellner reaches a similar conclusion, believing that we must 'go beyond Baudrillard to make his insights productive for aesthetic theory and practice today' (Kellner n.d: 4).

I disagree. Although Baudrillard's ideas are not always popular among artists and critics, and his survey of art is patchy in some respects, Baudrillard's writing still matters because it provokes a reaction and demands a response in turn. As a critic of the

contemporary art scene he challenges us to reflect on the process of art and its place within visual culture. Most important of all, Baudrillard's radical thought alerts us to what is at stake. Art is in denial about its disappearance, he tells us. His provocations demand that we pay attention. Baudrillard implores us to care.

Instead of taking the disappearance of art to signal that there can be no art (and that this is a bad thing) Baudrillard allows us to conceive of the destabilisation of the category of art quite differently. Art's disappearance takes on a new meaning in Baudrillard's writing, whereby in the act of disappearing (no longer being able to be defined/located through traditional aesthetic, economic, cultural categorisations), art is democratised so that it is everywhere and available to everyone. So it is not the 'loss' of art that Baudrillard is especially concerned with inasmuch as he is critical of the nostalgia expressed for an idea of art that no longer exits in a transaestheticised world. And how can we understand art when everything is art, when art is everywhere?

While we might be experiencing the end of representation, it is not, Baudrillard projects, the end of art. After all, Baudrillard himself is sufficiently interested in art to respond to it, even if this is not in conventional aesthetic or critical terms. With the disappearance of the art object has come the simultaneous proclamation of art's nullity. Yet it is this very inability to distinguish art from anything else that ensures that it is everywhere. There is more art than ever before. But there is a paradox here. Art disappears because there is too much of it. And the implication of art's excess is that it ceases to function as a critical medium once it becomes absorbed into everything else. Its power to surprise or present novel perspectives is diminished.

So where might this leave the artist, if their practice makes them part of an 'art conspiracy', however reluctant they might be to participate. And seemingly, the greater awareness an artist exhibits of this situation, the more complicit they become. Is the

artist defeated by the inevitability that whatever they produce can only ever be null, and that proclaiming this nullity puts another nail in art's coffin? Should we stop making art? looking at art? studying art? Of course not. I would suggest that Baudrillard's observations about the state of contemporary art can be used to understand better how art circulates in today's sign economy. It can help us to make sense of the trends and practices that prevail at this particular socio-historical moment.

And remember, making art and writing theory is not the same thing, as Baudrillard should know. As mentioned before, Baudrillard has acknowledged the separateness of these pursuits in his own life, even though they sometimes inadvertently collide. One such instance involves the exhibiting of his photographs at conferences devoted to his thought. At these moments he is both artist and intellectual, especially when he is present, as occurred at the West of the Dateline Conference held in Auckland in 2001. Another way that these two spheres merge is via analysis that simultaneously explores his photography and theory, as demonstrated in the writing of art theorists like Rex Butler. So while art practice and art theory are necessarily informed by each other and often converge, they can also be separate pursuits to be undertaken at certain moments and in specific spaces.

What we need to take away from Baudrillard's commentary on art, then, is an awareness of the art experience as an illusion that is produced and sustained. His complex and often contradictory theories are themselves constructed to stimulate thought about the changing nature of visual artefacts in an age of hyperreality where categories such as 'art', 'reality' and 'mass culture' are no longer absolutes, and in doing so prompt the artist and critic to re-examine accepted ways of approaching art. He raises new questions about who or what 'produces' art by recasting conventional wisdom about subject–object relations, which in turn challenges the primacy of the artist-as-subject.

Baudrillard sees hope for art, especially the photograph, as an instantaneous, irreversible and magic form that can draw us into the realm of duality and play. What he calls 'strange attractors' can still surprise us by generating singular moments or events that punctuate the banality of a simulated existence – much like Calle's shadowing game or the surgical performances of Orlan, an artist whose singularity, according to Victoria Grace, 'escapes all our coordinates...existing outside the limits of the law and its identity' (Grace 2007: 6). Unlike critical models of theory that aim to clarify, explain, interpret and ultimately 'know' the world, Baudrillard confuses dialectical ways of thinking. In his realm, there are no certainties.

Chapter 3

Consumption

Introduction

Keith Richards, the legendary guitarist and songwriter, and founding member of The Rolling Stones, is the latest celebrity to feature in Louis Vuitton's advertising campaign. Produced by Ogilvy & Mather, the campaign restates travel as the fundamental and defining value of Louis Vuitton, interpreting it as a personal journey and a process of self-discovery. In this latest visual, photographed by Annie Leibovitz, Keith Richards is pictured cradling his guitar in a hotel room he has transformed by draping black scarves with skull motifs over the lamps and placing a skull on a bedside table. The tagline states simply: 'Some journeys cannot be put into words. New York. 3 am. Blues in C'. (*Daily Mail*: 2008)

Sometimes, fashion campaigns (like this one) make you wonder about the role images play in selling commodities, as well as lifestyles and identities. It is a curious mix – the luxury label and the aging rocker with a reputation for hard living and a face as leathery as the bags he endorses. It's hardly surprising though, given that our visual sphere is littered with an endless and random parade of brands, images and graphics – all vying for the attention of buyers, and often using creative and provocative strategies to engage consumers. With the rise of 'lifestyle' culture, increasingly it is the symbols of leisure, enjoyment and indulgence that we seek out over and above any particular object, which never seems fully to satisfy us anyway. Even though we might not be able to afford Louis Vuitton luggage – or even to see the Rolling Stones

play a live stadium show, for that matter – we still fervently consume these things as images. So it is with *Shine a Light*, Martin Scorsese's 2008 documentary of the Rolling Stones in concert. It comes 38 years after the Maysles brothers filmed the youthful Stones in *Gimme Shelter*, and exactly 30 years since Scorsese directed the celebrated concert movie *The Last Waltz*, featuring American folk-rockers the Band.

This time around, the spectacle offered up for our viewing consumption is pure simulation – a concert staged for the purposes of producing a film. For some time Scorsese and Jagger toyed with the possibility of collaborating on a project, and so the idea for the movie preceded the actual concert (Lawrence 2008). More to the point, it *generated* the concert (technically two shows at the small Beacon theatre in Manhattan). Unhappy with the idea of filming the Stones in their usual stadium environs, Scorsese angled for an intimate venue that better suited his vision for the picture. Jagger was supposedly keen on capturing the band's 2006 performance in Rio in front of an estimated crowd of over a million (Reuters 2008). Instead, the Rolling Stones put on scaled-down shows for Scorsese, a modest number of fans, and an elaborate suite of film equipment. To say that the concerts at the Beacon theatre were simulated is not to say that other Rolling Stones shows aren't – after all that is the beauty of simulation. You can't tell the difference really. Yet the Stones insisted that they should not see the cameras while performing, despite staging these shows primarily for the purposes of making a film: '"If you know they are shooting a movie, then things change in the show and you don't capture something of it," says Richards' (Bunbury 2008). Ironically, the presence of so many cameras got in the way of fans being able to see the band up on stage, if reports from the *Guardian* are to be believed (Brown 2006).

To this end, *Shine a Light* inverts the traditional order of things in rock 'n' roll film-making, where the movie comes about via the concert. There was a time when we could say that without

the live concert there would be no movie, yet the shooting of *Shine a Light* complicates this view somewhat. This is especially so in an era where the purchasing of recorded music no longer drives the industry. With profits from music sales and distribution waning, increasingly it is the image that is generated and sold – made into a consumable product. Speaking about Scorsese's direction, Cosmo Landesman says, 'Instead of taking the band to the viewer, he takes the viewer to the band and dumps you right between the crouching Richards and the leaping Jagger' (Landesman 2008). This is even more true of seeing the film in IMAX format, where the concert-film is, to quote a U2 lyric, 'even better than the real thing' – or certainly bigger. And U2 should know. In 2007, they released a digital, 3D IMAX film of their Vertigo tour. With the title *U2 3D*, you can see the band much better than you would at a live show, with superior sound quality, and cheaper too.

Making sense of how and what we consume requires us to consider the operation of sign, information and media systems (forms), as well as what is displayed as an image (content). Or so says Baudrillard, whose preoccupation with consumer images and objects forms the basis of a number of his books, including *The System of Objects* (1996b), *The Mirror of Production* (1975), *The Consumer Society* (1998), *For a Critique of the Political Economy of the Sign* (1981) and *Symbolic Exchange and Death* (1993a). It is in these texts that Baudrillard demonstrates how consumption is related to culture. He does this by examining a number of visual fields – including art, advertising and fashion – in his discussion of the operations of consumption. This is significant, because it is through the process of describing the consumer society that Baudrillard highlights the importance of a representational economy to this emerging social order. That is, in identifying the rise of consumption, he also identifies a corresponding new visual landscape made up of mass-mediated images and texts. Moreover, Baudrillard's writings demonstrate the significance of signs to an

understanding of how we conceptualise objects, experiences and human relationships in the consumer age.

In order to chart Baudrillard's thoughts on the role that images play in consumer culture, I firstly describe and analyse the ideas put forth in *The Consumer Society*, where Baudrillard provides an accessible and systematic examination of object-signs. Within this framework I go on to discuss Baudrillard's writing on advertising, much of which is drawn from his book *The System of Objects*. During this phase Baudrillard is mostly concerned with the systems and structures that order social operations and determine meaning. This is vastly different to his writing on art, in which he rejects structural interpretations in favour of fatal strategies and implosive gestures such as seduction and simulation. When assessing Baudrillard's contribution to a study of consumption, what we need to keep in mind is that his ideas have evolved in accordance with constant changes to society. From his early theories, in which he conceptualises signs as a kind of language (elements in a coded system), to his subsequent efforts, in which signs become pure spectacle and appearance disconnected from a coherent system of meaning, Baudrillard develops new modes of thinking in order to theorise this constantly changing landscape. So in his later writings on fashion we begin to witness this shift towards a postmodern sensibility, which will also be discussed with respect to fashion imagery and brands. When Baudrillard writes about fashion, he necessarily scrutinises the body, which he argues has also become a sign-object of consumption itself. Perhaps nowhere is this more visible than the body of the fashion model. This chapter concludes, then, by considering Baudrillard's perspectives on the circulation of the body as a sign.

It is through an examination of Baudrillard's writing on advertising, fashion and the body that the role of consumption as a cultural and significatory process will be made apparent. This includes a study of various slogans associated with well-known

brands, the advertising campaigns of designer labels Chanel, Marc Jacobs and Louis Vuitton, as well as the analysis of programmes like *Sex and the City* and *Next Top Model*. These texts will be used to help demonstrate foundational ideas in Baudrillard's study of contemporary consumer culture, such as 'consumption', 'sign-exchange', 'symbolic exchange', 'spectacle', 'functionality' and 'recycling'. The trend for rejecting consumerism will also be assessed by looking at those practices broadly described as anti-consumerist. Like art, Baudrillard believes that consumer objects are everywhere: 'everything is spectaculatised, or, in other words, evoked, provoked and orchestrated into images, signs, consumable models' (Baudrillard 1998: 191). Because Baudrillard was one of the first thinkers to advance a theory of consumption that took into account the role and impact of signs, his ideas have much to offer those interested in analysing the visual spectacle of contemporary urban life, especially the commercial fields of advertising and fashion.

The consumer society

Throughout the 1960s and 1970s, Baudrillard – along with others such as Roland Barthes, Henri Lefebvre and the Situationists – analysed everyday life at a time of growing interest in the influence of culture on capitalist systems. This turn towards exploring cultural phenomena was prompted in part by the scant attention paid to such questions in a Marxist focus on the political and economic imperatives of capitalism. Throughout his early writings, Baudrillard moves away from a productivist paradigm as the means of understanding social structures and human behaviour. Despite this, George Ritzer rightly notes that Karl Marx – as well as classical sociological thinkers like Émile Durkheim, Marshall McLuhan and Daniel Bell – still exerts considerable influence on Baudrillard at this stage (Baudrillard 1998: 3–4). Hence Baudrillard's stance on consumption is in keeping with a more conventional sociological approach. Further, in this period

he is mainly concerned with Western culture and capitalist systems, as evidenced in his discussion of various phenomena like department stores, traffic jams, urban air quality, drugstores and pop art. In later writings, however, he confronts the dilemmas of consumerism in a global context. This leads us to question whether his theories regarding the ascendancy of consumption are still applicable in today's climate of multi-national corporations, global marketing and offshore production.

Few would dispute that we live in a consumer-oriented world. With industrialisation enabling the mass-production of goods and media advertising imploring us to buy, consumption has become a way of life. Yet the consumer society is more than a tagline for an era typified by the relentless purchasing of commodities. For Baudrillard, it is an entire *system* that organises individual and collective practices, relationships, beliefs, perceptions and attitudes. He argues that increasingly the order of production is becoming 'entangled' with that of consumption (Baudrillard 1998: 33). While once our role as producers within an industrial system defined who we were and how we lived our lives, Baudrillard says that it is as consumers that we now principally engage with the world. This is because people in modern times are

surrounded not so much by other human beings, as they were in previous ages, but by *objects*. Their daily dealings are now not so much with their fellow men, but rather – on a rising statistical curve – with the reception and manipulation of goods and messages. (Baudrillard 1998: 25)

So there is a representational, or communicative, dimension to consumption. In the schema outlined by Baudrillard, consumption is not primarily an economic activity, nor is it a means of fulfilling needs and experiencing personal pleasure. Rather, 'the subject of consumption is the order of signs' (Baudrillard 1998: 192). That is, consumption is first and foremost a signifying activity that occurs at the level of everyday life. As a system, or

'order of signification', the consumer society appropriates, organises and reproduces signs in a way that is not dissimilar to how language operates.

The significatory processes of consumption

What is distinctive about Baudrillard's take on consumption is its focus on objects as signs, rather than as material things. When he says, '*To become an object of consumption, an object must first become a sign*' (Baudrillard 1996b: 200), Baudrillard is emphasising that we are actually consuming signs over commodities:

The shop-window, the advertisement, the manufacturer and the *brand name*, which here plays a crucial role, impose a coherent, collective vision, as though they were an almost indissociable totality, as series. This is, then, no longer a sequence of mere objects, but a chain of *signifiers*, in so far as all of these signify one another reciprocally as part of a more complex super-object, drawing the consumer into a series of more complex motivations. (Baudrillard 1998: 27)

The process of buying something, then, is of less importance to Baudrillard than the system of organisation based on signs, where the consumer comes to make purchases through the codes determining one commodity from another. This idea is expressed in the process of shopping for a hat, which is not just driven by how useful the object might be. After all, every hat fulfils a basic function. So how and why do we differentiate between, for example, the headwear designed by an exclusive milliner like Philip Treacy, and a New York Yankees baseball cap? Baudrillard explains that we distinguish between the infinite array of objects on offer according to what they signify, which is determined relationally to each other. Rather than the value of a hat being determined by the cost of materials and labour used to make it, or its practical function to protect the head, its worth and social meaning is divorced from the cycle of production and use. The hat as commodity transcends material referents, so

that its significance and meaning is derived in relation to other constituents that form part of 'a social code of values' (Baudrillard 1998: 78). A couture headpiece can mean luxury, frivolity and absurdity relative to a knitted cap, which connotes warmth and simplicity, even though there is every possibility they cost roughly the same to make and may serve similar functions. Even two knitted caps can have comparatively different values within a coded system, depending on what is fashionable at any given moment, or whether the cap is branded with a label or handmade. In this sense, the worth of an object is not intrinsic to it – it does not have a pre-existing meaning but transcends material value to circulate among a host of other elements in a signifying chain. Consumption thus occurs 'at a distance, a distance which is that of the sign' (Baudrillard 1998: 33). It also means that purchasing a Philip Treacy couture headpiece connotes a certain lifestyle, because 'In buying one part of the system, one buys (into) the sign system as a whole: in more contemporary terms, one buys into a lifestyle, since buying any one sign function invokes the entire system of meaning' (Slater 1997: 146).

Another example of the primacy of the object-sign in consumer culture is the trend for giant designer handbags. Fashion's obsession with huge satchels is indicative of what Baudrillard identifies as a shift away from function determining the worth of an object towards functionality, where objects give the semblance of being functional but aren't actually very useful – like tail fins on a car (Baudrillard 1996b: 60). While these oversized totes give the impression that they are made to hold lots of things, it is unlikely that the starlets who hang them off their arms are carrying any more than what they would in a regular-sized bag. These objects have little added function beyond connoting status – they are even referred to as 'status bags' in the fashion press. They don't have to be useful, just signify usefulness through their design.

Consumption and social relations

So far we have considered how consumption operates at the level of the sign. But this is only one part of Baudrillard's argument about consumer society. In order to fully grasp the significance of signs in the consumer era, it is necessary to explore the link between consumerism and social formation. Baudrillard recognises that the process of sign-exchange that underpins consumerism is tied to human actions and relations. This is evidenced by the way he defines consumption as 'an unlimited social activity' whereby the manipulation of signs is in itself a form of social labour (Baudrillard 1998: 74). But the process of consumption doesn't just occur at the individual level. Our purchasing habits and choices have an impact beyond our own personal needs or pleasures. Baudrillard tells us that 'consuming is something one never does alone…One enters, rather, into a generalised system of exchange and production of coded values where, in spite of themselves, all consumers are involved with all others' (Baudrillard 1998: 78). Consumption has become another kind of code or language through which the members of a society can communicate messages to each other about themselves and their world.

Consumption thus plays an important part in the construction of collective and individual identity. And it is through the consumption of signs that Baudrillard argues identity is forged:

you never consume the object in itself (in its use-value); you are always manipulating objects (in the broadest sense) as signs which distinguish you either by affiliating you to your own group taken as an ideal reference or by marking you off from your group by reference to a group of higher status. (Baudrillard 1998: 61)

In other words, difference (or meaning) is generated by the circulation of symbols. And when status is to be found in signs rather than objects, identity becomes a process that is constructed through signs, rather than being pre-existing or 'innate'. Or, as Barbara Kruger's (1987) iconic artwork proclaims, 'I shop therefore I am'. We can see this in the way the characters in a series like *Sex and the City* come to be differentiated from

each other in terms of what they wear, which creates a sense of who they are as distinct individuals *relative to each other*. This is how the protagonists of the programme are described in a caption accompanying a photo from the official website:

Carrie is cocktail party ready in a Rebecca Taylor rainbow silk dress layered over Zara cargo pants and Christian Louboutin satin bow shoes. Miranda looks sharp in a pink pinstripe suit by Zenobia, Charlotte combines Chanel separates with a brown and white patent leather Louis Vuitton bag, and Samantha stands out in a Missoni skirt, an Armani halter and a Gucci satin jacket. (HBO n.d)

The *Sex and the City* website even has a page devoted to the 'look' of each character, comprised of a database of stills from each series accompanied by a description of the items worn according to designer label. So while the differences between Carrie, Charlotte, Samantha and Miranda are generated through

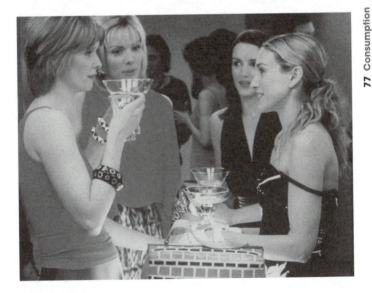

5. *Sex and the City*, TV still.

the manipulation of fashion signs, at the same time the brands they covet forge their group identity as financially secure, white, American women in a post-feminist era (Figure 5). The importance given to designer labels in *Sex and the City* also effectively illustrates the shift in the role of consumer goods in the modern and postmodern age. As Mark Poster explains, 'In modern society, consumer objects represented social status; in postmodernity, they express one's identity' (Poster 2004: 416). On another level again, *Sex and the City* realises the transformation of fashion-as-object into fashion-as-image – an idea I return to in the discussion of Baudrillard's writing on fashion later in this chapter.

Hence the way we create identity in contemporary society is not by surrounding ourselves with objects. Rather, signs are the mode by which value, status and selfhood are sought. This is an important point to stress because it is not the process of consuming – whether it be objects, services or experiences – that is fundamental here but the operation of signs. This is not to say that we don't actually buy and use these things. But how we make sense of them is in signified form. And it is precisely because consumption occurs at the level of the sign that our desire for things is never sated. This is evidenced by the fact that we can be surrounded by consumer objects, or have a wardrobe bulging with clothes, but still not feel satisfied. Accordingly, we want to buy more. In this case, Baudrillard believes that desire is driven by a need for social meaning, not actual objects. So if our desires are not generated by a basic need to accumulate consumer objects, can this explain the trend towards 'anti-consumerist' practices and beliefs?

Anti-consumerism

Another way that identities are constructed through consumption is by adopting a critical stance towards a consumerist way of life. There have always been those who have challenged consumption, or sought to opt out of the consumer lifestyle or limit their

involvement with it. There are many practices that we can point to as reactions against consumer society, like 'culture jamming', wearing second-hand clothing, buying 'green' products and participating in consumer boycotts. Yet rather than offering a way out of the consumer cycle, these acts in themselves become modes of communicating status and identity within a system of consumption. This is because social standing is not contingent on the goods a person accumulates but on *differences*, which explains why conspicuous consumption doesn't always translate into social capital (African American hip-hop artists and their 'bling' is one possible example). Conversely, those with money and status do not have to buy lots of things in order to retain social standing, but can participate in 'the paradox of "underconsumption", or "inconspicuous consumption", i.e. the paradox of prestigious super-differentiation, which is no longer displayed in ostentation (Veblen's "conspicuous consumption"), but in discretion, sobriety and self-effacement'. As Baudrillard goes on to explain, 'Differentiation may then take the form of the rejection of objects, the rejection of "consumption", and yet this still remains the very ultimate in consumption' (Baudrillard 1998: 90).

Limited consumption becomes an indicator of identity. It is fashionable for educated, well-off people to fret about their carbon footprint, purchase carbon credits and grow their own vegetables. They buy items from stores like the Body Shop, which favours environmentally friendly packaging, Fairtrade relations and non-sexist advertising. 'Dumpster-diving' is another trend – it involves foraging through giant bins at the backs of supermarkets for useable items and edible foodstuffs that have been thrown out because they are near their use-by date or have damaged packaging. Proving that trawling through trash-cans isn't just for the poor and homeless, the term was invented to explain the practices of those people with financial means who instead choose to take waste stuff for free. Apparently, supermarkets have taken to locking their bins at night in an attempt to prevent dumpster-diving.

If consumption is based in a coded system of signs, as Baudrillard claims it is, then a necessary part of the system is its remainder, or all those things deemed outside it. Those practices that we might broadly term 'anti-consumerist', or view as forms of alternative consumption, are hence part of a logic of consumption by virtue of being positioned as counter to traditional consumerist principles. By boycotting certain products deemed unethical or sourcing second-hand clothes, for example, we reinforce the code through which meaning is produced in the differential relation of signs to each other. That is, both consumption and what has been termed 'critical consumption' (Sassatelli 2006: 219) are part of the whole system of organisation that makes up consumer society. Just think about it – Naomi Klein's hugely popular book *No Logo* (2000), which rages against, among other things, the takeover of public space by signs has itself become an instantly recognisable logo, an emblem of anti-consumerism. Saying 'no' to sweatshop labour means turfing your Nike™ runners in favour of a pair of No Sweat™, ethically sound trainers. It's a matter of trading one brand for another.

This idea that everything is part of the system is also evident in the way that those things negatively associated with consumption (like global warming) are made out to have some purpose in advancing growth and affluence. Baudrillard maintains that in the consumer society waste has a positive function, which he illustrates in the following way:

The 30 per cent reduction in the luminosity of air in Paris over the past 50 years is regarded as external and non-existent by the accountants. But if it results in a greater expenditure of electrical energy, of light bulbs and spectacles, etc., then it exists – and exists, moreover, as an increase in production and social wealth! (Baudrillard 1998: 41)

In other words, consumer society relies on its negative aspects – it feeds off them in order to advance. For Baudrillard, things like

pollution are not only by-products, but central elements in the cycle of production and consumption. They take on a positive function in 'the production of values, differences and meanings on both the individual and the social level' (Baudrillard 1998: 43). Just as contemporary art proclaims it is like everything else by appropriating waste objects and refuse, the order of consumption subsists off its residue as a means of reproducing or sustaining itself.

While we seem to play an active part in defining ourselves through our consumer habits (or what we might call 'freedom of choice'), in another sense the codes that govern our value systems also operate at a deeper level. Baudrillard equates this process to language, where there are rules and codes built into the system that we take on board in order to exist as a subject in the world. And though consumer demand is created by contemporary capitalism to determine what people think they should need, this doesn't mean that consumers are wholly passive participants in the process, or that the pleasure derived from consumption is not real. For Baudrillard, it is production which creates a 'system of needs', and within this system individuals have 'consumption power' to pick, choose or reject certain objects (Baudrillard 1998: 75). What distinguishes the age of consumption is the cultural system of signs and symbols through which identity and meaning are gained. There is little doubt that advertising plays a central role in creating these needs and fuelling consumer desires. So it is to Baudrillard's scrutiny of the operations of advertising that we now turn.

Advertising

As demonstrated in the previous chapter, art was one aspect of culture that Baudrillard wrote about in order to document the increasing importance of consumption to social relations. Advertising features as another facet of everyday life through which Baudrillard offers insights into the shift in social and

semiotic practices after modernity. In a number of his writings Baudrillard has attempted to make sense of the way that advertising works as an expression of culture, rather than simply as a medium that provides information about a product. According to Baudrillard, advertising 'plays an integral part in the system of objects, not merely because it relates to consumption but also because it itself becomes an object to be consumed' (Baudrillard 1996b: 164).

In his book *The System of Objects*, Baudrillard argues that modern advertising is invested in the formation and maintenance of social meaning and the expression of the social order. This occurs in a number of ways. Firstly, advertising aims to gratify the consumer by using a mode of personal address that soothes, reassures and empowers. As a way of illustrating his argument, Baudrillard talks about an advertisement by armchair company Airborne, which uses pseudo-scientific speak combined with references to tradition to create a feeling of 'moral security' for the consumer. Not only are their chairs innovative and reliable, but Airbourne's advertising discourse uses terms like 'you' and 'yours' to imply that their products have been designed for the benefit of the individual consumer and adapted to suit their personal needs. So it is through the process of consuming the advertisement that one is made to feel important, individual and special, which means it is inconsequential whether the consumer actually goes out and buys an Airborne chair or not. Advertising has already made us feel good about ourselves, and what's more – it's free. With more than a hint of irony, Baudrillard likens advertising to a gift when he says that 'Objects are always sold; only advertising is offered gratis' (Baudrillard 1996b: 171–2). We come to believe in advertising not because we are convinced by the hard sell, but because advertising believes in us. 'Take care,' says Garnier. Nike tells us to 'Just do it'. It's 'Because you're worth it,' insists L'Oréal.

Although in one sense advertising is gratifying, Baudrillard argues that in another advertising frustrates the consumer. If the

role of advertisements is 'to draw attention to the absence of what they designate' then can consuming images ever satisfy desire (Baudrillard 1996b: 176)? Baudrillard observes that the discourse of advertising cannot deliver what it promises, but can only refer to other images within a sign network:

In the end the image and the reading of the image are by no means the shortest way to the object, merely the shortest way to another image. The signs of advertising thus follow upon one another like the transient images of hypnagogic states. (Baudrillard 1996b: 177)

The concept of the brand is understood by Baudrillard to operate in this way – as a series of empty signals. Subsequently, for Baudrillard the idea of brand loyalty is a misplaced sentiment, brought about by a process of manipulating signs.

It is by concurrently gratifying and frustrating the consumer that advertising regulates the society, according to Baudrillard. He takes issue with the way that advertising creates the perception of freedom, participation and agency in order to integrate the subject into society. In Baudrillard's words, 'the consumer internalises the agency of social control and its norms in the very process of consuming' (Baudrillard 1996b: 176). Moreover, behind the illusion of consumer agency that advertising creates, there exists a set of processes by which goods are produced. Advertising obscures this labour so that the goods we consume via the glossy images and seductive texts of ad-speak have no discernible history. They are simply 'there' for us to foster our own sense of individuality, as well as feelings of being one with the group.

In *The Consumer Society* Baudrillard extends this proposition to argue that the way something is advertised matters more than what is being advertised. We could say that Baudrillard is re-orienting his perspective on advertising to situate it more firmly in the mass-media moment. The manner in which television and radio advertising breaks up, juxtaposes, combines and delivers ads

in seemingly random patterns means we consume advertisements in their relation to other advertisements. For Baudrillard, it is the medium that shapes how we receive messages, and subsequently how we interpret them. He says,

It is not, then, its contents, its modes of distribution or its manifest (economic and psychological) objectives which give advertising its mass communication function; it is not its volume, or its real audience (though all these things are important and have a support function), but its very logic as an autonomised medium, i.e. as an object referring not to real objects, not to a real world or a referential dimension, but from one sign to the other, from one object to the other, from one consumer to the other. (Baudrillard 1998: 125)

When advertisements come to circulate relative to other signs, then they cease to offer meaning, or communicate anything. More to the point, deciphering whether the claims of an advertisement are true or false is irrelevant to Baudrillard because brands present us with a kind of self-fulfilling rhetoric. When Nike tells us to 'Just do it', purchasing the product confirms that it has been done. Buying L'Oréal products prove that you are indeed, as the advertisements insist, 'worth it'. Yet there is no way to prove empirically that one is 'worth it'. L'Oréal's claims, like those of many big brands, are not of the order of truth or falsity.

In *Simulacra and Simulation* Baudrillard goes as far as to say that the form of advertising is how all 'virtual modes of expression' operate (Baudrillard 1994b: 87). Consider a site like YouTube, where short clips echo the segmented and broken-up style of advertisements. Political campaigners condense their central policies into sound-bites, which are then put online for instant and easy digestion. On the Internet, the viewer can connect random bits of information just by clicking on various links. Television has gone this way too – consumers surf the vast number of channels available on cable TV in a way that mimics an ad-break. It is common to watch bits of different programmes

by switching from one channel to another. Or we watch multiple channels at the same time by breaking the screen into a series of smaller screens, each showing different events. This has become a popular way of simultaneously viewing a range of sports so that no important plays are missed. Because personal recording technologies like TiVo allow viewers to skip advertisements altogether, we find that product placement in movies and broadcasts is increasingly prevalent. Advertisers work at confusing the boundary between what is an advertisement and what is a programme. In *America's Next Top Model*, for instance, contestants undertake a task that involves shooting an advertisement for Cover Girl cosmetics. Viewing this episode necessitates watching endless takes of the wanna-be models struggling with the catchphrase 'Easy, breezy, beautiful Cover Girl' as they look down the barrel of the camera. As we watch the programme we are also watching an advertisement. There appears to be little power in wielding the remote control when entertainment and advertising have been thoroughly integrated into each other in a transaestheticised culture.

Fashion

While clothing and adornments have been with us since ancient times, it is on the role of fashion as appearance and seduction that Baudrillard's work contributes to studies of image culture. The fashion industry is largely a modern phenomenon, with its genesis in the period of emerging industrialisation and commercial expansion of the eighteenth and nineteenth centuries (Wilson 1985: 67–90). Technological advances during the twentieth century, which encouraged mass-production and mass media, have shaped fashion as we now know it (Breward 1995: 182–3). It is in this context that Baudrillard makes the observation that fashion, much like art, has entered into the realm of pure sign exchange, whereby meaning is no longer to be found in material objects but the relationship of signs to each other. This makes

Baudrillard's method somewhat different to other well-known sociological approaches to fashion. For a theorist like Thorstein Veblen, wealth is demonstrated through clothes. Excessive finery is a marker of 'conspicuous consumption', which in turn provides the wearer with social currency. Georg Simmel believes that fashion is used to demarcate between groups by signalling who one is as well as who one is *not*. It also provides an opportunity for members of a group to emulate the dress of another in the class hierarchy, and thus accrue status.[1] Perhaps most akin to Baudrillard's take on fashion is Roland Barthes's configuration of fashion as a kind of language, although by the time Baudrillard writes comprehensively about fashion, he no longer sees it purely in semiotic terms (Barthes 1967/1983).

Literature from the disciplines of art and visual culture has mainly focused on the realms of fashion photography and advertising. Some of this writing takes a psychoanalytic approach to read fashion imagery in terms of fetishism, desire and the gaze.[2] It is also concerned with exploring how images and appearances are implicated in the construction and maintenance of meaning about particular bodies and identities. The argument that fashion magazines promote particular stereotypes of race and gender is one example of this, as seen in the criticism of the March 2008 cover of *Vogue*, which shows African American basketballer LeBron James with one arm around the tiny waist of smiling blonde supermodel Gisele Bündchen. News reports liken the image to King Kong clutching Fay Wray, suggesting it reinforces racial stereotypes of black men as animalistic, dangerous and threatening, even though the *Vogue* cover is a pastiche of that iconic film moment (Scott 2008).

Rather than being concerned with whether changes in fashion mirror the socio-political landscape, or how images of fashion may be interpreted, Baudrillard's interest in fashion is as a form of sign exchange. It exemplifies a state of affairs in consumer society whereby the function of objects is of less importance than how

they circulate as signs. In *For a Critique of the Political Economy of the Sign* Baudrillard uses the example of changing hemlines to make this point:

Neither the long skirt not the mini-skirt has an absolute value in itself – only their differential relation acts as a criterion of meaning. The mini-skirt has nothing whatsoever to do with sexual liberation; it has no (fashion) value except in opposition to the long skirt. This value is, of course, reversible: the voyage from the mini- to the maxi-skirt will have the same distinctive and selective fashion value as the reverse; and it will precipitate the same effect of 'beauty'. (Baudrillard 1981: 79)

Baudrillard's most substantial proclamations on fashion appear in *Symbolic Exchange and Death* (1993a, originally published in 1976). Douglas Kellner describes Baudrillard's writing during this time as 'proto-postmodernist social theory', in that he seeks to document emergent trends at the decline of modernity and charts the shift towards a new phase that we now know as postmodernism (Kellner 1989: 95). Keeping this in mind, we can trace modern and postmodern tendencies in Baudrillard's writing on fashion.

In the chapter 'Fashion, or the enchanting spectacle of the code', Baudrillard explains that the power of clothing used to reside in its symbolic function. Dress played a role during ritual and ceremonial occasions to establish relations between people and groups. Within a symbolic register, clothing is not prized for its aesthetic look, its usefulness or its cost in an economic sense. Instead, it works along the lines of symbolic exchange – a social gesture through which objects circulate within social networks. In turn, as Victoria Grace notes, objects have symbolic power to transform human relations through the continual cycle of giving, receiving, returning and passing things on (Grace 2000: 19). Influenced by Marcel Mauss and George Bataille's writings on the gift, Baudrillard emphasises that in the symbolic order, what is being exchanged (the object or gift) matters less than the mode

of exchange, as it is via the process of reciprocal exchange that objects (such as clothing) accrue significance. Baudrillard says that modern fashion can't operate this way any more because in the process of becoming commodified, objects lose their symbolic function. As a sign, fashion can only give the appearance of ritual – 'fashion as spectacle, as festival, as squandering' (Baudrillard 1993a: 90). This results in the fashion system creating an illusion of its importance in the maintenance of collective relations, which conceals its inability to actually do so. As a result, we can only now experience fashion through a nostalgic recycling of past styles and forms (an idea I return to shortly).

Baudrillard tells us that fashion has also ceased to operate as a marker of wealth by differentiating classes according to the finery they could afford. He observes that 'Everyday consumer objects are becoming less and less expressive of social rank' (Baudrillard 1998: 57). The uptake of the luxury brand Burberry by working-class youth is a case in point. The distinctive Burberry check, which was once exclusively associated with English high society and A-list celebrities has become the favoured logo of 'chavs' – a term for British underclass youths who covet designer labels and ostentatious jewellery, which is combined with street apparel like baseball caps and tracksuits (McCulloch, Stewart and Lovegreen 2006: 554).[3] As the wealthy adopt more discreet forms of consumption, street fashion favours a *bricolage* of styles (Hebdige 1997). As an oh-so-visible sign of luxury, Burberry has become synonymous with football hooligans and minor soap stars – driven in part by the accessibility of the brand in the form of smaller, more affordable accessories, and the thriving industry of fakes that are near-impossible to distinguish from the real thing. Indeed, as Baudrillard would argue, discerning 'real' from 'fake' is not important, because the Burberry pattern (or sign) only needs to give the appearance of being real to bring about consequences and effects. Being hyper-visible has generated a crisis for Burberry, who in its quest for omnipresence (indeed,

universal brand recognition is the goal of any fashion label) risks compromising the exclusivity that the label trades on.

As far as Baudrillard is concerned, fashion is a perfect example of the liberation of the signifier in commodity culture. The signifier has free reign in the sense that fashion circulates in a way that is unbound to a referent in the material world: 'There is no longer any determinacy internal to the signs of fashion hence they become free to commute and permutate without limit' (Baudrillard 1993a: 87). Baudrillard demonstrates his point by locating fashion within a cycle whereby trends from earlier times are made new again. Each season brings with it a slew of 'new' collections, which are paraded down the catwalks and subsequently dissected in the fashion media. Yet, as an excerpt from the March 2008 edition of Australian *Vogue* demonstrates, the majority of these looks evoke past styles. Among the glossy pages they champion 'florals', 'fresh 50s', 'sheer', 'boy next door', 'boudoir baby' and 'hippie luxe' as directive looks for the coming season. This showcase of familiar cuts, patterns and colours lends credence to Baudrillard's claim that modern fashion 'is always and at the same time "neo-" and "*rétro-*", modern and anachronistic' (Baudrillard 1993a: 90). The co-existence of a multiplicity of fashion styles involves a play of signs, which makes it difficult to determine what is truly original, the origins of a certain style, or what could be classified as cutting-edge fashion.

At the same time, when object-signs are freed from their origins, we gain the impression that anything can be fashionable and fashion is endlessly available to everyone. This democratising element to fashion rests on the notion that 'fashion is a universal form…from which no-one is excluded' (Baudrillard 1993a: 92–4). Baudrillard sees right through this, arguing that fashion's popular associations with frivolity, accessibility and festival *only give the appearance* that fashion is a powerful social force which can function, among other things, to challenge the status quo and subvert the social order, as subcultural theories of style have

argued. According to Efrat Tseëlon, 'it is the ideology of consumption which creates an illusion of democratisation by promoting the myth of universal meaning of fashion, accessible to all' (Tseëlon 1994: 119).

Katharine Hamnett's protest T-shirts from the 1980s with catchphrases imploring us to 'CHOOSE LIFE' and 'SAVE THE WORLD' are an example of the trend Baudrillard forecasts. Hamnett even relaunched her slogan tops almost 20 years later in the wake of global environmental concerns and the atrocities of war, with one design stating 'NO MORE FASHION VICTIMS' (http://www.katharinehamnett.com). Since then, her tees have graced the slender frames of models and celebrities, who spread the word by appearing in the pages of fashion magazines and on celebrity gossip websites. Yet how meaningful are these politicised gestures? Not particularly, according to Baudrillard, who observes that 'In contradistinction to language, which *aims* at communication, fashion *plays* at it, turning it into the goal-less stake of signification without a message, hence its aesthetic pleasure, which has nothing to do with beauty or ugliness' (Baudrillard 1993a: 94).

To this extent, Baudrillard's writings suggest that fashion has no meaning. The diversity of fashion styles that typify the postmodern moment makes it harder to agree on what particular items stand for relative to others. When we think of a corset, a host of associations spring to mind – the gender constraints and class privilege of Victorian-era women, Madonna and female empowerment, bondage and fetish *aficionados*, gothic subculture. When signs have multiple meanings relative to an infinite number of other signs, meaning can't be fixed anywhere. Caroline Evans explains this well when she says,

the fashion garment circulates in a contemporary economy as part of a network of signs, of which the actual garment is but one. From its existence primarily as an object, the fashion commodity has evolved into a mutant form with the capacity to insert itself into a

wider network of signs, operating simultaneously in several registers. Whereas it used to exist as, for example, a dress, which preceded its single representation in the form of an advertisement or fashion photograph, it is now frequently disembodied and deterritorialised. As such, it can proliferate in many more forms, with a larger network of relations: as image, as cultural capital, as consumer goods, as fetish, art exhibition, item on breakfast television, show invitation, or collectible magazine. (Evans 2000: 96)

What we find is that the elements of the code come to exceed the system so that they no longer signify anything outside themselves.

In this respect, we can plausibly argue that fashion today has gone the way of art in a transaestheticised culture. Like art, fashion gives the illusion of being everywhere, yet its pervasiveness means that the category 'fashion' can't be pinned down or contained. Everything is fashion and nothing is fashion. Fashion is reflected in art and vice versa. One way this occurs is through uniting these two spheres to advance the vision of a particular luxury brand. Hermès, Cartier and Louis Vuitton all have exhibition spaces devoted to showcasing contemporary art. Often, artists are commissioned to design limited-edition ranges, like Tracey Emin's suitcases for luggage label Longchamp. Not long ago in Hong Kong,

French fashion house Chanel officially launched its latest global power project, the ambitious Mobile Art. Commissioned by Chanel's Karl Lagerfeld, the futuristic mobile art gallery was designed by the Pritzker Prize-winning architect Zaha Hadid. Created from fibreglass panels, the 700-square-metre multimillion-dollar pavilion took six months to build and will be dismantled seven times to travel the world. (Hush 2008)

According to Chanel's website (http://www.chanel.com) over 20 artists are involved in the project. Alongside the popular names like Sylvie Fleury, Yoko Ono, and Pierre and Gilles, artists working across a range of mediums are presented: photography (Stephen Shore, Nobuyoshi Araki), sculpture (Loris Cecchini, Subodh Gupta),

video (Tabaimo) and audio (Stephan Crasneanscki's Soundwalk). Even Sophie Calle, one of the few artists favoured by Baudrillard, has joined their ranks.

While the confluence of art and fashion is certainly not new, what these events suggest is that fashion is increasingly becoming indistinguishable from other aesthetic and commercial forms. We can think this through in relation to the advertising campaigns of major labels. In 2004 Chanel looked to film culture, hiring the director Baz Lurhmann to shoot an advertisement (or short film) starring actress Nicole Kidman. Marc Jacobs's most recent marketing campaign features singer and celebrity 'WAG' Victoria Beckham. In one photo she appears to be dancing – almost gliding – with her arms raised, left leg outstretched and eyes closed. In another she is encased in a giant Marc Jacobs shopping bag. As with most Marc Jacobs campaigns, it is famed fashion photographer Juergen Teller who is responsible for the grungy, amateurish and often unglamorous photos of indie celebs like the film directors Harmony Korine and Sofia Coppola, actors Winona Ryder and Charlotte Rampling, musicians Meg White from the White Stripes and Sonic Youth's Kim Gordon.

So, too, has the image of fashion itself become a commodity. Fashion advertising is not solely the representation of something we might buy, but has become an object of consumption in its own right – via magazines, television, film and the Internet. We consume consumption via the image, and in doing so go beyond a 'society of the spectacle' as Guy Debord and the Situationists understood it, whereby the whole world is remade as a series of visual representations (Debord 1967/1994: 98). Using the example of reality TV, Baudrillard argues that through the process of consuming the visual spectacle our relationship to images changes. Whereas in the society of the spectacle there is a distinction between images and reality (images alienate us from reality), in the era of hyperreality, we consume not only what is represented, but the medium through which it is represented,

thus blurring the distinction between the two. As a result, images like fashion advertising, magazines and catwalk shows no longer mediate between the real and the representational, but become our reality.

Looking at them another way, advertisements like those for Marc Jacobs – along with the Louis Vuitton campaign starring Keith Richards mentioned earlier – attempt to tap into the trend for rejecting fashion and its associations with beauty, perfect bodies and glamour. By using irony (in the depiction of a less-than-composed Victoria Beckham), photographing non-fashion icons (like Keith Richards) and avoiding high-fashion aesthetics (Teller's photos look like they belong in a family album), these ads imply that the truly cutting-edge goes beyond fashion trends. Yet this stance itself is a style statement, making the possibility of subversion difficult when everything (even rejecting fashion) is fashionable. Like anti-consumerism, anti-fashion is part of the fashion system, or as Baudrillard puts it 'We cannot escape fashion (since fashion itself makes the refusal of fashion into a fashion feature – blue jeans are an historical example of this)' (Baudrillard 1993a: 98).

These ideas anticipate Baudrillard's later postmodern theorising in the sense that fashion does not simply absorb other cultural signs but becomes indistinguishable from them. In an era of globalised culture, he says, jeans aren't just a fashion item but a kind of 'universal non-dress' that doesn't signify anything in particular about cultural identity, but has become a global object, like Coca-Cola and McDonald's. 'Could jeans be the ironic postmodern incarnation of Human Rights?' asks Baudrillard (Baudrillard 2003a: 33). Just as revealing is the way fashion becomes tantamount to celebrity, to the extent that the actual products hardly matter. Couture labels do not subsist on the sale of clothes. The prestige associated with a logo exists independently of the clothes and accessories it produces. Rather than being defined by the quality (exchange value) and functionality (use

value) of its designs, a brand's cachet is generated through its association with other famous names (sign value). Yet we can go one step further to argue that in an era of simulation there is no meaning behind the sign, as is suggested by the way that photographers, designers, models and celebrities are interchangeable in the circuit of meaning – if it's not Juergen Teller photographing Kim Gordon for Marc Jacobs, then it's Annie Liebowitz photographing Keith Richards for Louis Vuitton. And so it goes. Next season insert the name of another celebrity photographer, another cultural icon and another fashion house.

Put briefly, what we can discern from Baudrillard's study of fashion is this: it is because the symbolic register is latent that fashion becomes enchanting, pure and fascinating, says Baudrillard. In other words, what makes fashion so pleasurable and enjoyable is that it does not have a practical purpose when 'signifiers come unthreaded [*se défiler*], and the parades of the signifier [*les défilés du signifiant*] no longer lead anywhere' (Baudrillard 1993a: 87). What this tells us is that fashion is fundamentally about appearances – it seduces by connoting liberation, frivolity and availability, while obscuring a commercial basis that compromises fashion's ability fully to imbue or offer these qualities. Baudrillard makes a similar claim about the sexed body, whereby fashion gives the illusion of equality between the sexes (women wear trousers, androgyny reigns supreme) to hide the fact that gender inequality still exists.

The body

The body, it seems, has gone the way of advertising and fashion. It is destined to circulate as a sign. Baudrillard tells us that 'the production of the body, the production of death, the production of signs and the production of commodities – these are only modalities of one and the same system' (Baudrillard 1993a: 98). In *The Consumer Society*, Baudrillard makes the point that the body has become a consumer object *par excellence*, singling out

the female body as particularly susceptible to objectification via advertising and fashion. We invest in the body, which Baudrillard likens to an asset that needs to be maintained: 'one manages one's body; one handles it as one might handle an inheritance; one manipulates it as one of the many *signifiers of social status*' (Baudrillard 1998: 131). This regular upkeep can take the form of dieting, fitness, personal hygiene and beauty regimes, which suggests that the process of consumption has shifted to the site of the body and its projection as a sign.

When Baudrillard writes about the body in later texts, it has 'disappeared'. Instead of focusing on the relationship between images of the body and the construction of meaning within a representational economy, Baudrillard rejects any attempts to 'read' the body in this way, preferring to explore the mechanisms through which the body as we once knew it has been transformed through sign-exchange. He observes that the power of the body is neutralised when it becomes an object of fashion, subject to the vagaries of consumer imperatives (Baudrillard 1993a: 96). We can see this in the body of the model, which itself comes to be 'in fashion' or 'out of fashion' just like styles of dress are recycled season after season – a point Baudrillard derives from Roland Barthes's musings on the fashion system. Sometimes the fashion industry shows a preference for 'waifs', while at others times the statuesque Amazon type is in vogue. Even men's bodies are not immune to this cycle, with a fleeting obsession for slim-hipped boys replacing an earlier season's muscular look.

Moreover, we avidly consume an array of body styles as they circulate in the media. Reality TV programmes like *The Biggest Loser*, *What Not to Wear*, *Extreme Makeover* and *Next Top Model* give us the body-as-image. The body, understood as a solely material entity, disappears as it is made over through dress, exercise and surgery to signify an idealised fashion body. The BBC has even produced a programme titled *Britain's Missing Top Model*, which aims to be the 'UK's first TV competition for disabled

models' (Holmwood 2008). While the programme's spokespeople reason that it challenges conventional notions of beauty, raises awareness about disability and empowers women, a Baudrillardian logic suggests otherwise. The disabled body is mobilised as a commodity-sign in a way that resonates with Baudrillard's claim that we have entered the 'phase where everybody has become a mannequin – each is called, summoned to invest their bodies with the rules of the game of fashion' (Baudrillard 1993a: 99). What is at stake here is not so much the rights of disabled women, but the upholding of a reality principle that gives the illusion of championing 'real' bodies at a time when we fear losing the body to airbrushed, virtual and simulated images.

In other writings Baudrillard cites DNA, cloning technologies and virtual reality as examples of the way that the body is reconfigured as data in an era of hyperreality. He understands the body to be a simulation or *reality effect* based on the production of models with no basis in reality. This brings about an experience of the body *as* information – as genetic and binary codes rather than as a pre-given or innate biological entity. Of the possibility to clone bodies Baudrillard says, 'The DNA molecule, which contains all information relative to a body, is the prosthesis par excellence, the one that will allow for the indefinite extension of this body by the body itself – this body itself being nothing but the indefinite series of its prostheses' (Baudrillard 1994b: 98).

Commonly Baudrillard's insights about the body are misunderstood – taken to mean that that the material body no longer exists (e.g. Sobchack 1991). This is not Baudrillard's argument or intention. In seeing the body as an effect of the DNA or computer code, he is trying to explain firstly how our understanding of the body is mediated through images and models, and secondly the consequences of this for the body in a simulated landscape that blurs the distinction between the material and virtual.

Not all of the observations Baudrillard makes about the body are clear examples of his writings on the visual *per se* (which is what this book sets out to examine), but are worth noting at the very least to acknowledge Baudrillard's preoccupation with the body as a fatal form. For example, Baudrillard has discussed the obese body as 'a mode of disappearance for the body' (Baudrillard 1990a: 27). He is especially fascinated with those bodies that are considered anomalous – he cites Michael Jackson, Madonna and the Italian porn star La Cicciolina as examples – because they demonstrate the state of affairs whereby sexual difference disappears through an inexorable play between the signs of sex. These pop icons demonstrate that sex has become generalised. That is, sex has become a sign or a reference to be sited on the body, as opposed to constituting difference as it is experienced through the body. Notably, these 'mutants' or 'turncoats of sex', as Baudrillard refers to them (Baudrillard 1993b: 21) are not lauded by Baudrillard for their fetishistic qualities, or because they might challenge the status quo or social ideals, but because their confusion of the categories of sex generates indifference instead of revolution.

We can see this trend towards sexual excess and indifference in pornographic images, which Baudrillard considers to be emblematic of the circulation of hypersexual signs of sex in the media. Pornography doesn't generate an illusion of sex and sexuality (as it is assumed to do), because it blurs the line between the image and reality. Or put another way, in pornography 'sex is so close that it merges with its own representation' (Baudrillard 1990b: 29). 'Are they *really* having sex?' we ask. 'Is sex in front of a camera somehow fake sex?' Or 'Is this what it's supposed to look and *be* like?' Soon enough we lose interest – like we did with Paris Hilton's online bedroom antics – as there is nothing left to the imagination. Baudrillard suggests this is because everything is made entirely explicit and obvious in pornographic images. The naked body close up – especially the

genitals – is just *too* much, *too* real, a kind of 'over-signification'. For this reason, Baudrillard claims that pornography isn't seductive but obscene, by virtue of making everything visible. Nor does it get us any closer to the 'truth' about sexuality. In some instances, Baudrillard extends the idea of the pornographic beyond its sexual connotations so that the term is used to explain the promiscuity of all signs, not just those associated with sex.

Conclusion

What can we draw from Baudrillard's insights into consumer society – and visual spheres of advertising and fashion in particular – to make sense of the current operations of signs, brands and images? If, as Baudrillard tells us, consumption is a system of social organisation based on signs, then the logic of consumption can be understood in terms of the manipulation of signs. Fashion points to the colonisation of everyday life by signs. Take Louis Vuitton's overlapping 'LV' insignia or the two interlocking 'C's designed by Coco Chanel. Through being relentlessly plastered across all manner of objects, these logos have come to circulate independently of the bags, dresses, perfumes and shoes they adorn. They are no longer confined to clothing, accessories or makeup, even. For spring/summer of 2008, Chanel launched its own bike. Some might say it's a perfect complement to the label's surfboard, rugby ball and tennis racquets from a few seasons back. As Chanel's foray into sports equipment shows, brands have taken on a life of their own as signs that inhabit everything, and paradoxically no longer stand for anything in particular.

In his earlier writings, Baudrillard argues that it is through the manipulation of arbitrary and free-floating signs that society is structured. That is, signs make up part of a coded system of meaning that enables the distinctions between individuals and groups to be forged via the differential relations between object-signs. When we buy a pair of Prada pumps or Fairtrade coffee, it

is not simply goods that we are purchasing for practical use, but the social meaning attached to these items, which is accrued via their relationship of object-signs to each other. Or, as Douglas Kellner surmises,

In the consumer society, consumption thus replaces production as the central mode of social behaviour from which standpoint the society can be interpreted and critically analysed. Baudrillard thus conceives consumption as a mode of being, a way of gaining identity, meaning and prestige in the contemporary society. (Kellner 1989: 19)

Advertisements are duly implicated in the regulation of the consumer, playing a role in producing social relations and constructing a sense of individuality through the consumption of images.

In his subsequent observations on fashion, Baudrillard begins to move away from this position by revealing the mechanism by which fashion functions at the level of appearances and of simulation. When considered in light of Baudrillard's more recent theories, the Prada pumps and Fairtrade coffee don't secure meaning as much as obliterate it by circulating within a network of signs. Moreover, they circulate as sign-objects that provide the illusion of free choice and individuality via consumption in order to mask the absence of any meaning or 'deeper' significance among the infinite play of signs. We can think about the body this way too. We identify with our bodies, project ourselves onto them, focus on our appearance, and manipulate them as we would any other sign-object. The body is a simulated model to the extent that there is no 'real' body to be found behind the appearance. We have become signs.

Through his writings on advertising, fashion, consumption and the body, Baudrillard illuminates various stages in social organisation: from an era of symbolic exchange, where the object plays a unique role in social relations, through to a more

generalised system of use and exchange value that aligns the worth of an object with how it is made and used, then to the exchange of sign values whereby the manipulation of signs generates meaning via differentiation, and finally to a phase of pure simulation beyond signification where the circulation of signs creates an excess of meaning and reality. Yet Baudrillard does more than just map out a series of phases or provide a rationale for how signs work as carriers of meaning in the consumer age. In his later works especially, he becomes less concerned with deciphering the visual language of signs and codes and more interested in observing the commodification of everything (art, bodies, clothing), using this as a platform or starting point to provoke the viewer to think differently about the operations of the social and the constitution of real.

Chapter 4

Screens

Introduction

The realms of film, television and the virtual have long held a fascination for Baudrillard. A self-confessed film fan, he has spoken about the magic appeal of the cinematic experience, and often refers to movies when illustrating his theories. He has discussed *Pleasantville* (1998), Woody Allen's *The Purple Rose of Cairo* (1985), and *The Truman Show*, starring Jim Carrey (1998), to make a point about the transparency of the screen (Baudrillard 2005a: 198–9). In one of his best-known books, *Simulacra and Simulation*, Baudrillard looks to 1970s disaster film *The China Syndrome* (1979) as well as Francis Ford Coppola's war classic *Apocalypse Now* (1979) to demonstrate the operations of the reality effect. His later writings are littered with references to popular films as diverse as *The Piano* (1993), *Being John Malkovich* (1999) and *Minority Report* (2002). Television and computer screens also rate a mention. How could they not, given Baudrillard's reputation as feeder of the popular zeitgeist with his journalistic observations on all manner of cultural, social and political issues from Formula 1 racing and the *fatwa* on writer Salman Rushdie to 'mad cow' disease and the chess machine Deep Blue.

Amidst this preoccupation with the happenings of an ever-changing world, what is it about the screen that interests him so much? In this chapter I want to explore Baudrillard's thoughts on the role of images relative to electronic media, focusing specifically on reality TV and the depiction of war in the news

media and Hollywood film – areas that he has commented on at length. In doing so, the ideas and concepts presented in this chapter span a wide range of Baudrillard's books and articles, from early works like the essay 'Requiem for the media' in *For a Critique of the Political Economy of the Sign*, through to some of the last essays he wrote on terrorism and globalisation before his death in 2007. In order to understand better what Baudrillard has written about screen culture, it is useful to explore some of his theories of mass media and communication technologies. Concepts like the 'non-event' and 'the murder of the Real', as well as Baudrillard's interpretation of the voting process, are explained here. Although it is impossible to cover every aspect of what Baudrillard has written about the electronic media in one chapter, I do think that a selective overview of his key writings can help illuminate and clarify his approach to screen culture, which is especially relevant given the importance of television, film and digital images to the visual arts.

Initially inspired by Marshall McLuhan – the commentator who gave us the catchphrase 'the medium is the message' – Baudrillard extends this proposition to evaluate what happens to individuals and societies when visual technologies like film and television become central to human communication. Neatly explaining his position, Baudrillard says,

The 'message' of TV is not in the images it transmits, but the new modes of relating and perceiving it imposes, the alterations to traditional family and group structures. And we may go even further and say that, in the case of TV and the modern mass media, what is received, assimilated and 'consumed' is not so much a particular spectacle as the potentiality of all spectacles. (Baudrillard 1998)

This approach should be fairly familiar by now, given that our explorations of art, fashion and advertising so far have stressed that Baudrillard's methodology is quite different to that of other

analysts of visual culture. Rather than focusing on the content of images and their interpretation, he is more interested in reflecting on how images circulate, as well as their forms and effects in contemporary culture.

With the exception of his 1984 lecture-turned-book *The Evil Demon of Images*, Baudrillard doesn't spend much time distinguishing film as an experience or technology that is different to, say, television or computer games in its mode of communication. What he is more concerned about is observing how the distinction between these forms is eroding in the information age, and what this means for our sense of reality and illusion – especially in terms of the role images play in fostering our construction of these categories. Although we could accuse Baudrillard of not fully defining how the moving images he discusses differ from each other in terms of their audiences, formal and spatial aspects, or content, he is consistent in understanding each of these forms as no longer distinct from reality but of belonging to the order of hyperreality. That is, according to Baudrillard, television, film and computer screens don't just reflect a reality that is somehow separate from the 'real' world, but become our reality. The common thread that runs through Baudrillard's study of images on the screen is his preoccupation with the illusion of the world, and the consequences that arise when illusion – as well as reality – disappear.

Reality TV

Even though June Deery describes reality TV as 'the dominant new TV genre of the 21st century' (Deery 2004: 1), it was way back in the 1980s that Baudrillard identified and discussed the cultural significance of this now ubiquitous genre, making him one of the earliest commentators to do so. Baudrillard's main claim is that reality TV, or what he calls at times 'TV vérité', tells us more about the operations and effects of television and the mass media in a hyperreal age than it does about the private world of others. To

illustrate his point, he discusses the Loud family, who were filmed over seven months and their lives watched by millions of Americans during the 1970s (Baudrillard 1994b). In later writings, he turns his attentions to *Loft Story*, the French version of the reality TV phenomenon *Big Brother* (specifically Baudrillard 2005b; 2005d). What Baudrillard finds intriguing about these cases of reality TV is the hype that they generate, despite the fact that audiences are watching quite ordinary and often boring daily situations. In wondering why so many people are captivated by the banal routines of others, he poses various theories for our obsession with reality TV.

One aspect of reality TV that is particularly appealing to Baudrillard is the way that it mixes up, or complicates, the distinctions between the audience and the event, or the observer and what is being observed. Whereas once we considered the pictures on the TV screen as separate from what was going on in our living rooms, it seems that now we can't be so sure. For reality TV to exist, 'the viewer has to be brought not in front of the screen (he has always been there, and that is indeed his alibi and refuge) but into the screen, taken to the other side of the information set-up', Baudrillard tells us (Baudrillard 1996a). In an interesting twist, Baudrillard likens this interactive 'playing out' of reality TV to Duchamp's readymades to argue that 'we have all become readymades' in the sense that when an object or individual is taken out of one context and placed in another, an ambiguity, as well as a nullity, is created by this transference. Duchamp's bottle rack, for example, turns art – which was once revered as unique and different from ordinary things – into something mundane. Reality TV resembles the readymade in the sense that it kills off the distinction between once knowable categories. In doing so, it makes reality a useless term for explaining our existence relative to images – just as the readymade renders an everyday object useless by elevating it to an artform. Baudrillard argues that putting the viewer into the screen creates

an excess of reality that complicates the divide between television and reality to the point where what television presents us with is an 'ultra reality'.

What's more, every viewer is a potential reality TV contestant, who by virtue of existing is fully qualified to participate in a series of *Big Brother*. Just as audiences watch 'real life' on the screen, someone is watching them on CCTV monitors connected to strategically placed cameras in the city square, the shopping precinct and the airport. Webcams go even further by bringing the surveillance camera into personal spaces like the bedroom and living room. They allow for the documentation of a person's actions in the privacy of their own home and their circulation in real time across computer networks. It seems that the whole world can be visualised, making us all potential stars of the screen, whether we like it or not. Nor do we have much say in the matter. As Baudrillard observes in *The Perfect Crime*, the fact that we can be filmed anywhere and any time without knowing it turns us into 'actors in the performance' (Baudrillard 1996a: 26). More often than not someone is around who can take video footage with their mobile phone and then post it on YouTube. Online satellite maps like Google Earth allow your home to be located and viewed from anywhere in the world. You may be online, watched by millions and never be aware of your virtual presence. And it is when our existence is mediated through screens that we question the once concrete distinctions between television and life. Reality TV realises the 'dissolution of TV in life, dissolution of life in TV' (Baudrillard 1994b: 30).

In explaining this erasure of distance, Baudrillard insists that 'There is no separation any longer, no empty space, no absence: you enter the screen and the visual image unhindered. You enter your life as you would walk onto a screen. You slip on your own life like a data suit' (Baudrillard 2002: 177). This erasure is fuelled by reality TV's attempts to make the scenes that we are watching look unstaged, unscripted and natural. Its methods obscure the

fact that what we are watching is an illusion. Programmes like *Big Brother* do this by hiding those elements that might suggest we are viewing an artificial construct. These elements include cameras that record the contestant's every moves behind mirrored walls, and the use of regular people, rather than popular actors, in the *Big Brother* house (Figure 6). That said, the spin-off series *Celebrity Big Brother* complicates this idea even more by implying that watching famous people during their private moments will reveal insights into what they are 'really' like. Elements like these give the appearance of an indistinctness between life and the screen, along with a hypervisibility that seems better than or realer than ordinary existence.

Another related point that Baudrillard makes about reality TV is that the spectator has a new role in the viewing process – that of judge. When the hosts of Australian *Big Brother* proclaim

6. *Big Brother*, TV still.

that 'YOU have the power to decide', they are referring, of course, to the interactive voting process so common in TV competitions like *Big Brother*, *Dancing with the Stars* and the worldwide *Idol* franchise. When the viewer at home takes part in determining the outcome of the competition by voting for their favourites and voting off those they don't like, the relationship between the subject and the media changes. The viewer doesn't just passively watch the screen but seems to become involved in the events being portrayed in a way that affects the outcome of the programme. Some media analysts applaud this trend, seeing it as proof that TV audiences are not lazy, unresponsive and disengaged consumers but active participants in the TV-watching ritual.[1] Taking a different stance, Baudrillard suggests that the increasing interactivity between the viewer and the screen (which also includes the Internet, video games, multimedia etc.) actually diminishes any distance from which the viewer might cast a moral judgement. Through interactivity, the viewer is no longer outside the screen. Instead, practices like voting implicate the viewer in the event to the point where they actually play a part in determining its outcome. Baudrillard claims that 'The television universe is only a holographic detail of global reality. Down to our most daily existence, we are already in a situation of experimental reality. And that is where the fascination comes from, from immersion and spontaneous interaction' (Baudrillard 2005a: 182).

While a process like interactive voting complicates the perception of television as a one-way form of communication that transmits information to a passive receiver who can't respond, what is important to note here is that Baudrillard doesn't think this gives viewers any more power or agency. For Baudrillard, the televisual emphasis on participation, interactivity and media convergence makes it harder for audiences to escape the mediasphere. Rather, whenever we text to vote off an annoying housemate, post our thoughts on a blog or take part in an online opinion poll, we become more and more immersed in

communication technologies, to the point where the subject and the masses become part of the information circuit. This becomes a problem for Baudrillard when these technologies demand our immediate attention. Because they don't allow much room for contemplation or critical distance, Baudrillard thinks that we are losing the art of meaningful communication or dialogue. So the interactive voting that is often championed as a form of audience participation is recast as a kind of non-response by Baudrillard.

Baudrillard has spoken about the electoral system in these terms, claiming that a referendum-style 'yes/no', 'accept/reject' format abstracts the process of communication by narrowing it down to a set of predetermined responses (Baudrillard 1981: 171). This idea can be applied to TV polls and voting processes, where the response is already there for the voter – the answer has been decided in advance by the question posed to the viewer. When the programme's host asks 'Who should be evicted from the *Big Brother* house?' audiences can only vote for the few options they are given. Because feedback is fixed within an already existing pattern (housemate A, B, C etc.), any attempt at communicating something different, spontaneous, original or beyond this predetermined set of answers is impossible. What this means is events like public-opinion polls and audience voting give the appearance of individual empowerment and democracy but actually create its opposite – indifference. As with the case of art appreciation discussed in Chapter 2, audiences are aware of how popular-opinion polls work, so they become complicit in a game of call and response, in which the polls 'no longer really ask questions and masses…no longer reply' (Baudrillard 2002: 189). Both just play along with the semblance of communication. It's a kind of staging of communication or a simulation of a response, if you like. After all, who really cares whether housemate A or B is voted out – nothing is really at stake, nothing much will change in the *Big Brother*. The show must go on. Baudrillard interprets this audience non-response as a strategic tactic used by the masses

to beat the system at its own game. The more fixed the questions and answers TV polls throw at us, the more mindless and random responses we instantly flick back.

On another level, Baudrillard considers reality TV programmes like *Big Brother* to be typical of the tendency towards visualising everything – from the mundanity of brushing one's teeth to the equally personal intimate whispers between housemates as they lie in bed after dark, picked out by night-vision cameras. What we are consuming is not just the content of these shows, but access to what we perceive to be a hidden reality. Baudrillard refers to this as a 'forced visibility', which he argues is typical of how all images circulate nowadays, and when 'everything is given to be seen, we discover that there is nothing left to be seen' (Baudrillard 2003c: 174). It would be wrong to think that we accumulate more information about contestants on *Big Brother* by seeing dimensions of their private lives that we might not otherwise be privy to – how they take their tea, their naked bodies, the way they put their socks on. For Baudrillard the opposite is true. The more we see, the less we know. If we accept Baudrillard's take on how the media works, then the truth behind the image will always elude us because there isn't one. Baudrillard explains that we can never know absolute reality because the seemingly unscripted, unmediated and entirely transparent nature of reality TV is in fact an 'artificial microcosm' or 'human zoo' that can only give the illusion of a real world. The problem is that we don't know it's an illusion because any semblance of illusion has been eradicated by hypervisibility of the scene, which seems too real not to be true. We are watching a simulation. And as we know from the first chapter, one of the key conditions of hyperreality is too much information.

Baudrillard has used a number of terms to describe this phenomenon across his writing. What he calls the 'murder of the Real', the 'zero degree', 'obscenity', is characterised by a disappearance that comes about because there is too much of

everything – we are saturated by an endless parade of images, ranging from the banal to the explicit, which seem to come at us from everywhere and all the time. This notion of disappearance is quite different to conventional thinking, whereby disappearance is associated with something being absent or lacking, and the obscene elements of culture are often censored, prohibited and marginalised. Baudrillard's vision of the world is one where everything is transparent and made visible. This pushes society to the point where it reaches an ecstatic state typified by an overload of information, data, signs, interpretations and opinions (Baudrillard 1990a: 11). *Big Brother* assaults us with too much reality, which generates more information in the form of online blogs, the show's website, 24-hour live streaming on the Internet, numerous opinion pieces and articles in the popular press and wider media, as well as academia. Being bombarded with so many images and texts across a range of media risks taking us to a point where nothing is left to the imagination, resulting in very few instances of genuinely novel situations, new encounters or fresh perspectives. When every possibility is exhausted, when all scenarios have been imagined and played out, the potential for secrecy is all but eradicated. Baudrillard thinks that this excess of meaning manages to violate the image because any ability that images once had to capture the mystery and illusion of reality is shattered when everything is made visible to us.

Virtual war

The violence that is done to the image in contemporary TV formats can also be said to play out in war imagery. Arguably, Baudrillard's most controversial and topical writing is on postmodern warfare and its representation in the mass media. Yet well before he began contemplating depictions of the Gulf War or the attacks on the World Trade Center and its aftermath, Baudrillard wrote about the visual documentation of the Holocaust. Prompted by a 1970s TV drama of the same name,

Baudrillard questions whether television can ever truly capture the horror of an event like the mass genocide carried out by Nazi Germany during World War II. Unlike critics who think that these types of TV reconstructions serve as reminders of the atrocities of war to prevent them being replayed (except on the screen, it seems), Baudrillard suggests that television can't provoke fear and revulsion commensurate with the scale of this event. Sure, it may give viewers a sense of 'being there', but they are hardly in danger when taking it all in from the comfort of their living rooms (Baudrillard 1998: 34).

More radically, perhaps, Baudrillard likens the fictional reconstruction of the Holocaust to the gas chamber. Both technologies annihilate lived experiences, emotions, memories and history. In the case of television, the event is recast through dramatic portrayals that aim to get us closer to the truth of the situation but instead create the opposite effect of distancing us from the actual event. This experience of distance is not one of being alienated from a supposed 'truth' that is hidden behind 'false' images. What Baudrillard is talking about is more like being saturated with so many images that we can't determine what the original is any more. It is this consumption of events like the Holocaust from a distance – retrospectively as well as through a sea of images – which makes television a 'cool' technology, as opposed to the 'hot' immediacy and singularity of the moment of war, which is lost when it is filtered through media networks (Baudrillard 1990b: 161).

Some time later, Baudrillard returned to exploring the effects of media portrayals of war in a series of controversial articles about the Gulf War. Respectively titled 'The Gulf War will not take place', 'The Gulf War: is it really taking place?' and 'The Gulf War did not take place', together they provide a useful assessment of the impact of televised images on Western perceptions of contemporary warfare. Although news and fictional images of earlier wars have been screened on television (like the Holocaust

drama mentioned above, or footage of the war in Vietnam or the Falkland Islands), the Gulf War was unique for the vast amounts of live media coverage it generated. It was a war depicted in 'real time' on our TV screens. In a more general sense, Baudrillard's response to this media moment can tell us something valuable about the changing nature of images and their role in a mediated world. His notion that we are moving away from the actual towards the virtual as our dominant mode of conceptualising reality gives visual-arts proponents a way of understanding how images operate in the electronic age.

What does Baudrillard mean when he says 'the Gulf War did not take place'? And what part have images played in generating this perception? It can be argued, as a critic like Christopher Norris does, that Baudrillard turns a blind eye to the fact that lives were lost and horrendous damage and destruction caused by this seemingly 'virtual' war. He accuses Baudrillard of paying more attention to virtual images than the material reality 'behind' the virtual images (Norris 1992). The general view – one shared by Norris – is that the Gulf War *did* take place. It involved real people and real events, and to suggest that it didn't happen because lots of the footage shown on television looked like a computer game is absurd. Other critics, namely Victoria Grace (Grace 2000), William Merrin (Merrin 2005) and Paul Patton (Patton 1995), reject Norris's reading as way off the mark. They defend Baudrillard on the grounds that he is observing a new type of warfare driven by electronic media and virtual images, rather than simply saying that nothing happened.

Baudrillard highlights that what is occurring in our current media landscape is a case of 'exchanging war for the signs of war' (Baudrillard 2005c: 62). War has become virtualised in the sense that our understanding of it is filtered through media footage that is put together to provide the semblance of a real event. Because of a lack of images to act as evidence that the war was occurring, networks instead created the perception of war by televising a

steady stream of 'talking head' experts, graphs and maps, intelligence reports, night-vision footage of missile attacks, and opinion polls. As far as Baudrillard is concerned, these media tactics did more to construct a vision of the war, than to actually report on events as they occurred.

Looked at this way, Baudrillard isn't necessarily ignoring the suffering of war, but criticising the construction of the war via media images, which denies our perception of the event and distances us from it. In fact, Baudrillard is at pains to note the obscenity of this virtualised mode of war, which did not seem to effect discernible change to the global order or ensure the safety and well-being of Americans, Kuwaitis or Iraqis, despite the death and destruction it generated and the widespread media coverage it elicited. So it is in the context of war being eroded under the weight of its own image that Baudrillard claims 'the Gulf War did not take place'. It is also important to recognise, as Baudrillard does, that the Gulf War wasn't like those of the past, where troops

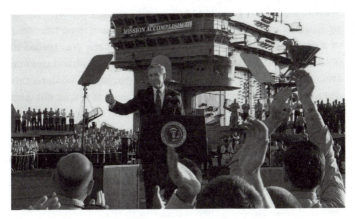

7. George W. Bush with banner stating 'MISSION ACCOMPLISHED'.

faced each other on the battlefield or in the air, each with a shared idea of what war meant and involved. War as we once knew it is changing: 'war is not measured by being waged but by its speculative unfolding in an abstract, electronic and informational space' (Baudrillard 1995: 56). The enemy appears at a distance as a computerised target, allowing for smart bombs, heat-seeking missiles and other devices to be engaged from the computer screen. Under these circumstances, one has to wonder where war is taking place and who the enemy is. A war conducted in virtual space also makes it harder for media to 'prove' that war is happening through the use of photojournalistic images, hence the reliance on the signs of war by news outlets. At the same time, the abstract and indeterminate nature of contemporary warfare makes it harder to discern when a war is over, as the following section on the 'non-event' illustrates.

One of the most useful insights Baudrillard offers us to understanding the changing nature of the moving image is the idea of the 'non-event'. Television coverage of the Gulf and Iraq Wars is a good example of the non-event, as it is conceptualised by Baudrillard. Like TV news reporters who arrive on the scene of a disaster before emergency services, the Iraq War traded in such moments. Take the toppling of the statue of Saddam Hussein from its pedestal in central Baghdad. Aided by US soldiers, this seemingly spontaneous gesture of Iraqi freedom played out with the cameras rolling. The ease with which TV news cameras managed to document what was claimed to be an unprompted and spur-of-the-moment act became the talking-point of the news media. Speculation about the staging of this moment for television and news media came to overshadow the actual event. In other words, television no longer simply reports on events, it becomes an event in itself – and then reports on it.

For Baudrillard, it is when television attempts to erase any temporal or spatial delay between the event and its coverage that the actual situation risks being subsumed by the TV moment, 'lost

in the void of news and information' (Baudrillard 2005c: 122). When a banner proclaiming 'MISSION ACCOMPLISHED' was displayed behind US President George Bush in 2003 to accompany his declaration of the end of major combat in Iraq (Figure 7), most of the subsequent media debate involved speculating on the truthfulness of this claim rather than reporting on the end of the war. The supposed information provided by the government and media can be understood as an attempt to generate the event – making the Iraq War end by visually and verbally sending us the message that it has ended. By anticipating the end of the war, its potential conclusion becomes a non-event, upstaged by Bush's pre-emptive message. In this sense, the semblance of victory is more important than actual victory, which is harder to pin down in a visual depiction. Instead, the end of the war is anticipated and eclipsed by media images like the broken statue of Saddam Hussein and the 'MISSION ACCOMPLISHED' banner. The tendency Baudrillard is describing here isn't confined to TV news reporting, though. This situation – where the medium starts to generate events instead of depicting them – is a problem that affects television and other broadcast forums more generally, from reality TV to Internet streaming.

At the same time, the Iraq War was a non-event because it was based on preventing Saddam Hussein's regime from using against the West weapons of mass destruction that were never verified to have existed. This pre-emptive gesture precedes the event, so that 'the crime is nipped in the bud on the strength of an act that has not taken place', and thus stops a possible event from occurring (Baudrillard 2005c: 118). Baudrillard cites the Steven Spielberg film *Minority Report* to demonstrate this point, alluding to the role police play in the film to arrest criminals before they commit an offence. The problem is, there is no way of knowing whether the situation would have played out as predicted if the intervention had not taken place. But the non-event isn't just about preventing things in the future, but also works retrospectively, as is the case

with the wars in Afghanistan and Iraq, which 'aim to defuse the terrorist event of 11 September' through eradicating the enemy, and in turn, the humiliation, death and suffering that ensued from the twin towers attacks (Baudrillard 2005c: 119). These descriptions show that the non-event isn't a case of nothing happening, but of trying to make something happen before it actually occurs.

While the wars in the Gulf, Afghanistan and Iraq are deemed 'non-events' by Baudrillard for the reasons outlined above, he puts September 11 in another category altogether. He considers the destruction of New York's twin towers to be one of the rare instances of what he calls an 'absolute event' in contemporary culture, because what occurred on that day is outside the realm of pre-existing frameworks of understanding (Baudrillard: 2003b). It could not be predicted or foreseen. It was utterly catastrophic. When the images of September 11 flashed up on our TV screens 'how many of us first thought, somehow, *this must be the movie channel*' (McMillan and Worth 2003: 120). How else could we possibly make sense of what we were seeing? What we tend to find, however, is that these moments of rupture are swiftly reabsorbed into the hyperreal mode by the media. The attack conforms in many ways with the non-event in the sense that it was instantaneously beamed around the globe in real time to audiences who avidly consumed an 'image event', described here by William Merrin:

The crucial moments and footage of the plane's explosion, the fireball's growth and the tower's collapse and spreading dust clouds were continuously repeated, blurring temporality: As Sky News unnecessarily added, relishing the detail, 'slow motion pictures reveal *the full force and horror* of the crash...' (Merrin 2005: 102)

At the same time as recognising the hyperreal nature of September 11, Baudrillard concedes the unintelligibility of this event by noting that while the CIA had intelligence pointing to the

possibility of a terrorist attack, even they couldn't predict something like this occurring – 'It was beyond imagining' (Baudrillard 2005c: 133). This kind of event – one that cannot fit into our known frames of reference, which forever changes the way we perceive the world – is what Baudrillard describes as a singularity. How can such an act be matched? Surpassed? Responded to? It is a force that Baudrillard claims is hardly present any more, as he observes in his study of art, which like the media non-event, seems only to replay what has come before.

Post-September 11 films

News coverage of war on the small screen has its complement in Hollywood portrayals of America's military involvement in the Middle East and its after-effects. After a series of Gulf War films, which included *Courage Under Fire* (1996), *Three Kings* (1999) and *Jarhead* (2005), came those dealing with US occupation of Afghanistan (*Lions for Lambs* [2007]) and most recently the Iraq War. In the latter category we can single out *Home of the Brave* (2006), *Redacted* (2007), *In the Valley of Elah* (2007), *Battle for Haditha* (2007) and *Stop-Loss* (2008) as distinct, for their focus on the personal cost to American soldiers on their return to civilian life. Generally, the moral of these stories is that the consequences of war come home to roost. Most of these movies are based on actual events and seek to expose the failure of the US invasion of Iraq at home and abroad. They explore how war has damaged individuals, families and communities without eradicating the global threat of terrorism. Interestingly, very few of these films were critical successes, and most were written off as box-office flops. Even though Brian de Palma, the director of *Redacted*, believes that 'The pictures are what will stop the war. If we get these pictures and stories in front of a mass audience, maybe it will do something' (Corliss 2007), up until now his strategy doesn't seem to have worked so well. And if audience reception to this type of movie is anything to go by, interest in visual depictions of

the war in Iraq is waning at a rate that inversely correlates with their escalating production. This phenomenon was picked up on by American comedian Jon Stewart in his opening speech as host of the 2008 'Oscars' ceremony:

Not all films did as well as *Juno* obviously. The films that were made about the Iraq war, let's face it, did not do as well. But I'm telling you, if we stay the course and keep these movies in the theatres we can turn this around. I don't care if it takes 100 years. Withdrawing the Iraq movies would only embolden the audience. We cannot let the audience win.

Like former president George W. Bush's decision to stick with an unsuccessful and unpopular war, the continual assault on cinemagoers with unsuccessful and unpopular cinematic portrayals of the war in Iraq doesn't appear to be drawing more fans. Nor can we register a discernible shift in people's perceptions and attitudes towards the war as a result of these films.

How do we make sense of this strange irony? After all, there appears to be a general consensus that war is hell and suffering continues for those involved long after the fighting has ceased. And despite their lack of mainstream success, why shouldn't these movies play a part in helping us better understand the dire effect and realities of war? I'm pretty sure Baudrillard would not disagree on either of those counts. Possibly, we could put it down to audience taste, or maybe just concede that these are 'bad' films, although what counts as a 'good' or 'bad' film is highly debatable. And anyway, who is to say that 'bad' film-making equates to box-office failure? Perhaps the answer lies beyond a judgement of the quality of these films to attract audiences. Baudrillard's style of thinking can come in useful here because it asks us to reorient this question so that we consider images in another way – that is, beyond aesthetics, taste or critical interpretations (a point that I have stressed in earlier chapters). Rather than questioning whether these films present an alternative

'truth' about the 'war on terror', or considering their relevance to a better understanding of the hidden effects of war on ordinary people – an approach that Baudrillard would consider as revealing very little about the operations of images in contemporary culture – a Baudrillardian focus would question why these moving pictures have generated such an indifferent response, especially given the topicality and gravity of the subject matter being portrayed. His theories can help us account for the failure of these films at this particular time.

One of the ways Baudrillard suggests we can explain this kind of indifference is to think about how this group of films contributes to the virtualisation of war, and what kinds of reactions this shift from the actual to the virtual generates. The 2007 release *In the Valley of Elah*, directed by Paul Haggis, offers a neat example of the consumption of war – and its traumatic after-effects – as a sign. Constant reference to the screens of information and communication technology throughout the film is one mechanism by which the movie screen itself is virtualised or, put another way, utilised to create a sense of reality. Right from the outset, it is made apparent that personal communication technologies are a central component of the film's narrative, plot and form. For a movie that claims to be inspired by actual events, these devices give the semblance that the viewer has access to an alternative account of the war in Iraq – a reality that is usually obscured by all the gloss and spin of mainstream media.

The film begins with some undecipherable visual footage. Its fragmented and pixellated grain makes it seem as though we are watching a corrupted digital file or a scratched DVD. This footage appears at various points throughout the film, hinting at the circumstances yet to be deciphered. This uncertainty drives the movie, which revolves around the disappearance of a soldier gone AWOL shortly after returning home to the United States from a stint in Iraq. The soldier in question is Mike Deerfield, whose father Hank receives a phone call about his son's disappearance

in a scene just after the opening sequence. Immediately after putting down the telephone Hank checks his email for news from his missing son, then calls him on his mobile. No word from Mike. What we can be certain of, however, is the film's reliance on the virtual screens of the mobile phone and computer to reconstruct the pattern of events surrounding Mike's disappearance.

In another early scene we see Hank watching news coverage of the war on television. This public version of events can tell him little about his son's experiences, his predicament and his whereabouts. A retired military policeman, Hank takes matters into his own hands, stealing his son's mobile from the army barracks where he was last seen and getting the phone analysed in the hope that he can retrieve enough data to find out what happened to his son. It seems that the video files on Mike's phone are corrupted. What little the technician can retrieve is incomplete and damaged, although a section showing American troops playing football with Iraqi children is discernable. Presumably it is Mike's unit. It is now apparent to the viewer that the grainy, broken-up footage at the start of the movie was from Mike's phone. The technician offers to unscramble the rest of the data and email each file through to Hank. It will take a while, we are told, hence setting the pace for the unravelling of events throughout the film as each bit reveals another piece of the puzzle of Mike's experiences in Iraq.

To get to the bottom of this mystery, Hank relies on more images – this time some digital photos Mike had taken and sent to his parents – documenting his tour of duty. He scours this 'evidence' for clues, with little luck. Any hope of finding his son alive is shattered when Mike's burned remains are found and Hank finds himself poring over forensic photographs of his son's charred body. Soon enough Hank receives more digital footage from Mike's phone, which, along with other sources of personal documentation he collects, enables him eventually to piece together the truth about what went on in Iraq and the circumstances

leading to his son's death. It turns out that Mike was killed on American soil, in cold blood, by the soldiers who had been his friends. Yet Hank isn't vengeful when he uncovers the truth. The cruel realities of war that Mike captured on his phone explain to Hank (and the viewer) how individuals become desensitised to human suffering through the experiences of warfare.

There are certainly resonances here with Baudrillard's observation about *Apocalypse Now* being a case of war becoming film and film becoming war. Similarly, in a movie like *The China Syndrome*, from 1979, Baudrillard makes the point that the film generates the effect of reality by constructing everything outside the screen as 'real'. We can see a similar things happening in a film like *In the Valley of Elah*. By relying on 'documentary' evidence in the form of digital photographs and video footage, the screen serves to provide us with an alternative version of events, a personal narrative of the effects of war that is distinct from the 'official' line proffered by the military, politicians and the media. The virtuality of these films pivots on the use of unmediated images – digital data whose function is to act as a form of proof, and so imply the 'truth' or actuality of the trauma of war from the perspective of an insider.

Furthermore, the use and depiction of virtual screens of personal communication technologies on the cinematic screen operates to downplay the film's status as a fictional reconstruction. It attempts to represent a reality, to offer another vision or version of events. The way that this is undertaken through the use of digital devices is significant. The film-makers could have drawn on other filmic conventions, like flashback scenes, to convey to the audience Mike's experiences. By documenting the soldier's account of the war, as captured by do-it-yourself forms of communication, those once personal or unknowable situations that soldiers go through are made visible. Any of the uncertainty or mystery of what happened in Iraq, as well as what occurred to Mike once he went AWOL, is fully exposed to the viewer. War is

understood via the process of making once-private information public through interactive and virtual information technologies. By letting the viewer into the insider's world of war through mobile phone video, emails and alike, the movie generates the sense that we are witnessing a side of war otherwise 'hidden' from view.

In this scenario, we are not simply consuming the story being represented in the film, but the mediums by which the content is being represented. Any message these films might convey 'disappears on the horizon of the medium' (Baudrillard 1984: 23). What ensues, Baudrillard suggests, is a situation whereby the image can no longer mediate between representation and reality. Images become our reality of war, not a representation of it. Baudrillard concludes that the image's ability to act as a representation is denied by its lack of differentiation from reality when the image telescopes with that reality. Daily life for soldiers in Iraq becomes cinematographic – their intimate experiences are made accessible to everyone in an act of oversignification that leaves nothing to the imagination. As a result of watching screens within screens, the trauma and suffering brought about by war is experienced as information.

So while one could argue that the indifference of an audience to these films could simply be put down to 'war fatigue', a Baudrillard-inspired interpretation suggests another cause. If we take it to be the case that images are what generate our reality, then it is more accurate to call this a case of 'image fatigue' or 'reality fatigue'. Instead of convincing people of the injustices of war through the portrayal of American soldiers returned home, an excess of reality in the form of immersive virtual technologies has created indifference, which is the opposite effect to that intended. For Baudrillard, cinema is no longer an 'enchanted universe' that generates a sense of illusion by being different to reality (Baudrillard 1984: 23). Baudrillard calls for a return to illusion as an antidote to the 'integral reality' we are experiencing, and which he claims creates an indifference to images of suffering. In the

cross-over from illusion to disillusion, the image has lost its critical function. This is the violence that is done to the image. The question he leaves us with is how do we reinstate the power of the image? And is it even possible?

Screened out

Screened Out (2002) is the title of one of Baudrillard's books. An apt one, I think, given the changing nature of images in an age of instantaneous and pervasive electronic media. What is the fate of the image – and the subject, for that matter – when everything becomes screened out? And where does this leave the visual-arts scholar, critic and practitioner when one can no longer speak about 'representation' on the screen as something different to 'reality' outside the screen? Baudrillard shows us how these distinctions become complicated in the information age. Through his writings about various modalities of screen culture, Baudrillard provides us with a way of analysing the role of images in the mass media in terms of an 'ultra reality'. Instead of understanding televisual, filmic and computerised images as illusions that reflect or represent reality, they are recast by Baudrillard as our reality. This is in part due to instantaneous forms of media like reality TV and live news footage of the war, which chip away at conventional notions of time, space and distance. When television itself, rather than what it depicts, becomes the focus, television loses its function to provide information. What we get instead, as with the case of the Gulf War, is television that promotes information to construct an event.

This confusion has been helped along by the convergence of media forms. As we see in the case of *Big Brother*, programming isn't confined to the TV set. We can also watch the show on the Internet via webcasts that are streamed live 24 hours a day. Often, controversial events that are edited from the daily programme later appear on YouTube, as was the case with the notorious 'turkey slapping' incident that occurred during the sixth season of the

Australian franchise. It involved a female housemate being held down by a male housemate while another rubbed his genitals over her face. Even though the incident happened in the early hours of the morning and did not appear on television, those watching the live Internet feed certainly saw it, and it was subsequently made available online to watch, generating an enormous amount of traffic once the event was picked up and reported by the media, including TV news. What this incident tells us is that we don't just watch the TV screen for entertainment any more. Instead we turn to the Internet to make sure we don't miss a second of what is going on with reality TV contestants, and to follow up on issues and events by getting online and trawling for more and more information. Like the point made in the previous chapter about the embedding of ads in TV shows, the visual examples discussed in this chapter illustrate the changing way we watch moving images when once-neat distinctions like those between the television and the computer screen, or between editorial and advertising content, are blurred.

Further Reading

Throughout this book I have mobilised images from popular culture and the art scene to show how Baudrillard's key concepts lend themselves to studies of the visual. I have also taken a closer look at Baudrillard's wide-ranging and sustained commentary on many aspects of visual culture (like television, art and fashion) to consider its relevance to the field. Yet it would be remiss to think that Baudrillard is only important to the visual arts. As demonstrated by the comprehensive bibliography of writings about Baudrillard compiled by Richard Smith (in Zurbrugg 1997), the French thinker's wider influence on contemporary critical thought is considerable, and continues to engage scholars at the forefront of inquiries into the operations of political, social, economic and cultural life. More recently, the formation of a journal devoted to scholarship on Baudrillard – the *International Journal of Baudrillard Studies* – is testament to the currency of his ideas and their applicability across disciplinary fields.

A number of books offer useful further reading on Baudrillard's body of thought. A sound general introduction is Richard Lane's *Jean Baudrillard* of 2000. Mike Gane (1991) and Douglas Kellner (1998) offer vastly differing critical overviews in their respective, well-known studies. Victoria Grace's germinal feminist appraisal of Baudrillard's *oeuvre* – *Baudrillard's Challenge: A feminist reading* (2000) – is highly recommended, as is *Jean Baudrillard: The defence of the real* by Rex Butler (1999). Other notable contributions to the Baudrillard scene include Charles Levin's *Jean Baudrillard: A study in cultural metaphysics* (1996), Gary Genosko's *Baudrillard*

and Signs: Signification ablaze (1994) and more recently *Jean Baudrillard: Live Theory* by Paul Hegarty (2004). Of course, the best way to encounter Baudrillard is to read his own words. A selection of his works are listed in the bibliography.

Hopefully this book has helped readers glimpse another Baudrillard, even if only momentarily. He is no more or less real than the one we presume to know but circulates as another incarnation – or simulation – that comes to the forefront when we consider him in terms of what he has written about the visual. But just as we think we have grasped him, he becomes something else. We can liken Baudrillard to a trickster who, through his writing, teases, provokes and forces us to keep looking at culture in new ways and from new perspectives. Like the world he observes, Baudrillard's thoughts are in a state of perpetual movement, making him and his ideas impossible to pin down. This book stands as a modest attempt to illuminate a fragment of Baudrillard's elusive philosophy for a particular time and in a certain moment. As new audiences encounter his ideas, there is little doubt that Baudrillard will continue to generate novel commentary, creative analysis and fresh responses to his work and the world at large.

Notes

Introduction

1 For studies of film see Arthur W. Frank (1992) 'Twin nightmares of the medical simulacrum'; Diane Rubenstein (1992) 'The anxiety of affluence: Baudrillard and sci-fi movies of the Reagan era'; Alan Cholodenko (2004) '"The borders of our lives": Frederick Wiseman, Jean Baudrillard, and the question of the documentary'.

2 The writing of Rex Butler predominates in studies of photography and Baudrillard: Rex Butler (2003) 'Jean Baudrillard: photographing ethics'; Rex Butler (2005) 'Baudrillard's light writing or photographic thought'.

3 Examples of television analysis utilising a Baudrillardian approach include Kevin Glynn (2003). 'Tele-visions of the otherworldly: the seductions of media culture'; Kathleen Dixon and Daniela Koleva (2007) 'Baudrillard and history and the hyperreal on television, or some women of the global village'.

4 See, for example, Timothy W. Luke (1994) 'Aesthetic production and cultural politics: Baudrillard and contemporary art'; Kim Toffoletti (2003) 'Imagining the posthuman: Patricia Piccinini and the art of simulation'.

Chapter 3

1 For a good general introduction to sociological theories of fashion, I recommend Peter Corrigan (1997) *The Sociology of Consumption*.

2 See, for example, Rosetta Brookes (1992) 'Fashion photography: the double page spread: Helmut Newton, Guy Bourdin and Deborah Turberville'; Chapter 5 of Jennifer Craik (1994) *The Face of Fashion: Cultural studies in fashion*; Valerie Steele (1996) *Fetish: Fashion, sex and power*.

3 For more on this phenomenon, see Claire Bothwell (2005) 'Burberry versus the chavs'.

Chapter 4

1 Indicative of this position are Philippe Meers and Sofie VanBauwel (2004) 'Debating *Big Brother* Belgium: framing popular media culture'.

Selected bibliography

Bal, Mieke (1996) 'Reading art?', in Griselda Pollock (ed.) *Generations and Geographies in the Visual Arts: Feminist readings*, London and New York: Routledge.

Barthes, Roland (1967/1983) *The Fashion System*, trans. Matthew Ward and Richard Howard, New York: Hill and Wang.

Baudrillard, Jean (1975) *The Mirror of Production*, trans. Mark Poster, New York: Telos Press.

(1981) *For a Critique of the Political Economy of the Sign*, St Louis, MO: Telos Press.

—— (1983/1990) *Fatal Strategies*, trans. Philip Beitchman and W.G.J. Niesluchowski, New York and London: Semiotext(e)/Pluto.

—— (1984) *The Evil Demon of Images*, Sydney: Power Institute.

—— (1987) 'Please follow me', *Art & Text,* vol. 23, no.4.

—— (1990a) *Fatal Strategies*, New York and London: Semiotext(e)/Pluto.

—— (1990b) *Seduction*, Basingstoke and London: Macmillan.

—— (1992) 'Transpolitics, transsexuality, trasaesthetics', in William Stearns and William Chaloupka (eds) *Jean Baudrillard: The disappearance of art and politics*, New York: St Martin's Press.

—— (1993a) *Symbolic Exchange and Death*, trans. Iain Hamilton Grant, London, Thousand Oaks, CA, New Delhi: Sage Publications.

—— (1993b) *The Transparency of Evil: Essays on extreme phenomena*, trans. James Benedict, London and New York: Verso.

—— (1994a) *The Illusion of the End*, trans. Chris Turner, Cambridge and Oxford: Polity Press.

—— (1994b) *Simulacra and Simulation*, Michigan, MI: University of Michigan Press.

—— (1995) *The Gulf War Did not Take Place*, Bloomington and Indianapolis, IN: Indiana University Press.

—— (1996a) *The Perfect Crime*, London and New York: Verso.

—— (1996b) *The System of Objects*, trans. James Benedict, London and New York: Verso.

—— (1997a) 'The Art of Disappearance', in Nicholas Zurbrugg (ed.) *Jean Baudrillard: Art and artefact*, London, Thousand Oaks, CA, New Delhi: Sage Publications.

—— (1997b) 'Objects, images, and the possibilities of aesthetic illusion', in Nicholas Zurbrugg (ed.) *Jean Baudrillard: Art and artefact*, London, Thousand Oaks, CA, New Delhi: Sage Publications.

—— (1998) *The Consumer Society: Myths and structures*, London, Thousand Oaks, CA, New Delhi: Sage Publications.

—— (2000) 'Photography, or the writing of light', *CTheory*.

—— (2001) *Fragments*, trans. Chris Turner, London and New York: Routledge.

—— (2002) *Screened Out*, London and New York: Verso.

—— (2003a) 'The Global and the Universal', in Victoria Grace, Heather Worth and Laurence Simmons (eds) *Baudrillard West of the Dateline*, Palmerston North: Dunmore Press.

—— (2003b) *The Spirit of Terrorism and Other Essays*, New York and London: Verso.

—— (2003c) 'The Violence of the image and the violence done to the image', in Victoria Grace, Heather Worth and Laurence Simmons (eds) *Baudrillard West of the Dateline*, Palmerston North: Dunmore Press.

—— (2005a) *The Conspiracy of Art*, New York and Los Angeles: Semiotext(e).

—— (2005b) 'Dust breeding', in *The Conspiracy of Art*, New York and Los Angeles: Semiotext(e).

—— (2005c) *The Intelligence of Evil or the Lucidity Pact*, Oxford and New York: Berg.

—— (2005d) 'Telemorphosis', in *The Conspiracy of Art*, New York and Los Angeles: Semiotext(e).

—— (2005e) 'Violence of the virtual and integral reality', *International Journal of Baudrillard Studies*, vol. 2, no.2.

—— (2005f) 'War porn', in *The Conspiracy of Art*, New York and Los Angeles: Semiotext(e).

BBC News (2007) 'Warhol's Liz Taylor sold for $23m', 14 November (retrieved 3 March 2008), http://news.bbc.co.uk/go/pr/fr/-/2/hi/entertainment/7092265.stm.

Borger, Julian (2006) 'Hit TV crime show helps criminals cover their tracks', *Guardian*, 8 February (retrieved 29 April 2008), http://www.guardian.co.uk/media/2006/feb/08/usnews.broadcasting/print.

Bothwell, Claire (2005) 'Burberry versus the chavs', BBC News, 28 October (retrieved 11 March 2008), http://news.bbc.co.uk/1/hi/business/4381140.stm.

Breward, Christopher (1995) *The Culture of Fashion*, Manchester and New York: Manchester University Press.

Brookes, Rosetta (1992) 'Fashion photography: the double page spread: Helmut Newton, Guy Bourdin and Deborah Turberville', in Juliet Ash and Elizabeth Wilson (eds) *Chic Thrills: A fashion reader*, London: Pandora.

Broude, Norma and Mary D. Garrard (eds) (2005) *Reclaiming Female Agency: Feminist art history after postmodernism*, Berkeley, CA and London: University of California Press.

Brown, Mark (2006) 'Rolling...Scorsese to direct documentary on the Stones', *Guardian*, 2 November (retrieved 15 April 2008), http://www.guardian.co.uk/uk/2006/nov/02/musicnews.film.

—— (2008) 'Art bucks recession fear', *Guardian*, 6 February (retrieved 4 March 2008), http://www.guardian.co.uk/uk/2008/feb/06/artnews.art.

Buchloh, Benjamin H.D. (2000) *Neo-Avantegarde and Culture Industry*, Cambridge, MA and London: MIT Press.

Bunbury, Stephanie (2008) 'Martin Scorsese and controlling Stones', *Age*, 5 April (retrieved 15 April 2008), http://www.theage.com.au/news/film/martin-scorsese-and-controlling-stones/2008/04/03/1206851099858.html.

Burger, Peter (1984) *Theory of the Avant-garde*, trans. Michael Shaw, Manchester: Manchester University Press.

Butler, Rex (1999) *Jean Baudrillard: The defence of the real*, London, Thousand Oaks, CA, New Delhi: Sage Publications.

—— (2003) 'Jean Baudrillard: photographing ethics', in Victoria Grace, Heather Worth and Laurence Simmons (eds) *Baudrillard West of the Dateline*, Palmerston North: Dunmore Press.

—— (2005) 'Baudrillard's light writing or photographic thought', *International Journal of Baudrillard Studies* vol. 2, no.1.

Cholodenko, Alan (2004). '"The Borders of our Lives": Frederick Wiseman, Jean Baudrillard, and the question of the documentary', *International Journal of Baudrillard Studies*, vol. 1, no.2.

Corliss, Richard (2007) 'Iraq war films focus on soldiers', *Time*, 1 September (retrieved 7 May 2008), http://www.time.com/time/arts/article/0,8599,1658403,00.html.

Corrigan, Peter (1997) *The Sociology of Consumption*, London, Thousand Oaks, CA, New Delhi: Sage Publications.

Craik, Jennifer (1994) *The Face of Fashion: Cultural studies in fashion*, London and New York: Routledge.

Daily Mail (2008) 'Rolling Stone Keith Richards takes time out from rock 'n' roll to model for Louis Vuitton', 3 March (retrieved 18 March 2008), http://www.dailymail.co.uk/pages/live/articles/showbiz/showbiznews.html?in_article_id=525069&in_page_id=1773.

Debord, Guy (1967/1994) *The Society of the Spectacle*, New York: Zone Books.

Deery, June (2004) 'Reality TV as advertainment', *Popular Communication*, vol. 2, no.1.

Dixon, Kathleen and Daniela Koleva (2007) 'Baudrillard and history and the hyperreal on television, or some women of the global village', *International Journal of Baudrillard Studies*, vol. 4, no.2.

Evans, Caroline (2000) 'Yesterday's emblems and tomorrow's commodities: the return of the repressed in fashion imagery today', in Stella Bruzzi and Pamela Church-Gibson (eds) *Fashion Cultures: Theories, explorations and analysis*, London and New York: Routledge.

Foucault, Michel (1984) 'Nietzsche, genealogy, history', in *The Foucault Reader*, ed. P. Rabinow, London: Penguin.

Frank, Arthur W. (1992) 'Twin nightmares of the medical simulacrum: Jean Baudrillard and David Cronenberg', in W. Stearns and William Chaloupka (eds) *Jean Baudrillard: The disappearance of art and politics*, New York: St Martin's Press.

Gane, Mike (1991) *Baudrillard: Critical and fatal theory*, New York and London: Routledge.

Genosko, Gary (1994) *Baudrillard and Signs: Signification ablaze*, New York and London: Routledge.

Glynn, Kevin (2003) 'Tele-visions of the otherworldly: the seductions of media culture', in Victoria Grace, Heather Worth and Laurence Simmons (eds) *Baudrillard West of the Dateline*, Palmerston North: Dunmore Press.

Grace, Victoria (2000) *Baudrillard's Challenge: A feminist reading*, London and New York: Routledge.

—— (2003) 'Medical visualisation: ontological politics and paradoxes', in Victoria Grace, Heather Worth and Laurence Simmons (eds) *Baudrillard West of the Dateline*, Palmerston North: Dunmore Press.

—— (2007) 'Orlan – Strange Attractor', *Theory and Event*, vol. 10, no.4.

Graw, Isabelle and Martin Carpenter (2000) interview, http://ourworld. compuserve.com/homepages/merlincarpenter/talk.htm.

Greenberg, Clement (1939/1961) 'Avant-garde and kitsch', in Clement Greenberg (ed.) *Art and Culture: Critical essays*, Boston: Beacon Press.

Greer, Germaine (2008) 'Through a Lens Darkly', *Age*, 2 June (retrieved 2 June 2008), http://www.theage.com.au/opinion/through-a-lens-darkly-20080601-2kgo.html?page=-1.

HBO (n.d.) *Sex and the City* section, HBO website, (retrieved 13–15 April 2008), http://www.hbo.com/city.

Hebdige, Dick (1997) *Subculture: The meaning of style*, London and New York: Routledge.

Hegarty, Paul (2004) *Jean Baudrillard: Live theory*, London and New York: Continuum.

Holmwood, Leigh (2008) 'TV show searches for disabled model', *Guardian*, 5 March (retrieved 18 March 2008), http://www.guardian.co.uk/ media/2008/mar/05/bbc.television1?gusrc=rss&feed=media.

Hush, Kellie (2008) 'Art in the bag', *Age*, 6 March (retrieved 10 March 2008), http://www.theage.com.au/articles/2008/03/05/12044025178 11. html.

Jameson, Fredric (1991) *Postmodernism, or, the Cultural Logic of Late Capitalism*, Durham, NC: Duke University Press.

Jermyn, Deborah (2007) *Crime Watching: Investigating real crime TV*, London and New York: I.B.Tauris.

Jinman, Richard (2008) 'Traces of Banksy worth a motza', *Sydney Morning Herald*, 16 January (retrieved 4 March 2008), http://www.smh.com.au/articles/2008/01/15/1200159448644.html.

Kellner, Douglas (n.d.) 'Jean Baudrillard and art' (retrieved 6 March 2008), http://209.85.173.104/search?q=cache:OZRV66xcBBAJ:www.gseis.ucla.edu/faculty/kellner/essays/baudrillardandart.pdf+Baudrillard+art&hl=en&ct=clnk&cd=1&client=safari.

—— (1989) *Jean Baudrillard: From Marxism to postmodernism and beyond*, Oxford: Polity Press.

Landesman, Cosmo (2008) 'Shine a light', *Sunday Times*, 13 April (retrieved 15 April 2008), http://entertainment.timesonline.co.uk/tol/arts_and_entertainment /film/film_reviews/article3720858.ece.

Lane, Richard (2000) *Jean Baudrillard*, London and New York: Routledge.

Lawrence, Will (2008) 'Martin Scorsese and Rolling Stones on the making of shine a light', *Times*, 22 March (retrieved 15 April 2008), http://entertainment.timesonline.co.uk/tol/arts_and_entertainment/film/article3576763.ece.

Levin, Charles (1996) *Jean Baudrillard: A study in cultural metaphysics*, London and New York: Prentice Hall.

Luke, Timothy W. (1994) 'Aesthetic production and cultural politics: Baudrillard and contemporary art', in Douglas Kellner (ed.) *Baudrillard: A critical reader*, Oxford and Cambridge: Blackwell.

McCulloch, Ken, Alexis Stewart and Nick Lovegreen (2006) '"We just hang out together": youth cultures and social class', *Journal of Youth Studies*, vol. 9, no.4.

McMillan, Karen and Heather Worth (2003) 'In dreams: Baudrillard, Derrida and September 11', in Victoria Grace, Heather Worth and Laurence

Simmons (eds) *Baudrillard West of the Dateline*, Palmerston North: Dunmore Press.

Meers, Philippe and Sofie VanBauwel (2004) 'Debating *Big Brother* Belgium: framing popular media culture', in E. Mathijs and Janet Jones (eds) *Big Brother International: Formats, critics and publics*, London and New York: Wallflower Press.

Merrin, William (2005) *Baudrillard and the Media: A critical introduction*, Cambridge: Polity Press.

Nead, Lynn (1987) 'The Magdalen in modern times: the mythology of the fallen woman in Pre-Raphaelite painting', in Rosemary Betterton (ed.) *Looking On*, London, Boston, Sydney, Wellington: Pandora.

Norris, Christopher (1992) *Uncritical Theory: Postmodernism, intellectuals and the Gulf War*, London: Lawrence and Wishart.

Patton, Paul (1995) 'Introduction', in *The Gulf War did not Take Place*, Bloomington and Indianapolis: Indiana UP.

Pollock, Griselda (1988) *Vision and Difference: Femininity, feminism and histories of art*, London and New York: Routledge.

Poster, Mark (2004) 'Consumption and digital commodities in the everyday', *Cultural Studies*, vol. 18, nos 2/3.

—— (2006) *Information Please: Culture and politics in the age of digital machines*, Durham, NC and London: Duke University Press.

Reuters (2008) 'Scorsese's Rolling Stones film set for US release', *Age*, 1 April (retrieved 15 April 2008), http://www.theage.com.au/news/film/scorseses-rolling-stones-film-set-for-us-release/2008/03/31/1206850798309.html.

Rincon, Paul (2005) 'CSI shows give "unrealistic view"', BBC News, 21 February (retrieved 29 April 2008), http://news.bbc.co.uk/go/pr/fr/-/1/hi/sci/tech/4284335.stm.

Rojek, Chris and Bryan S. Turner (eds) (1993) *Forget Baudrillard?*, London and New York, Routledge.

Rubenstein, Diane (1992) 'The anxiety of affluence: Baudrillard and sci-fi movies of the Reagan era', in William Stearns and William Chaloupka (eds) *Jean Baudrillard: The disappearance of art and politics*, New York: St Martin's Press.

Ruscoe, Kim (2008) 'Bail for man charged with killing tagger', *Stuff*, 22 February (retrieved 4 March 2008), http://www.stuff.co.nz/4411228a10.html.

Sassatelli, Roberta (2006) 'Virtue, responsibility and consumer choice: framing critical consumerism', in John Brewer and Frank Trentmann (eds) *Consuming Cultures, Global Perspectives: Historical trajectories, transnational exchanges*, Oxford and New York: Berg.

Scott, Megan K. (2008) 'LeBron James *Vogue* cover criticized', Associated Press, 24 March (retrieved 31 March 2008), http://sports.yahoo.com/nba/news?slug=ap-voguecover&prov=ap&type=lgns.

Slater, Don (1997) *Consumer Culture and Modernity*, Cambridge and Oxford: Polity Press.

Sobchack, Vivian (1991) 'In response to Baudrillard: Baudrillard's obscenity', *Science-Fiction Studies*, vol. 18, no.3.

Steele, Valerie (1996) *Fetish: Fashion, sex and power*, New York: Oxford University Press.

Stuff (2008) 'Glacier tagger gets frosty treatment', 26 February (retrieved 4 March 2008), http://www.stuff.co.nz/4411228a10.html.

Toffoletti, Kim (2003) 'Imagining the posthuman: Patricia Piccinini and the art of simulation', *Outskirts: Feminisms Along the Edge*, no.11.

Tseëlon, Efrat (1994) 'Fashion and signification in Baudrillard', in Douglas Kellner (ed.) *Baudrillard: A critical reader*, Oxford and Cambridge: Blackwell.

Wilson, Ashleigh and Sanna Trad (2008) 'Police put Bill Henson child pornography charges to DPP', *Australian*, 31 May (retrieved 4 June 2008), http://www.theaustralian.news.com.au/story/0,,23786367-16947,00.html.

Wilson, Elizabeth (1985) *Adorned in Dreams: Fashion and modernity*, Berkeley, CA: University of California Press.

Zurbrugg, Nicholas (1994) 'Baudrillard, modernism, and postmodernism', in Douglas Kellner (ed.) *Baudrillard: A critical reader*, Oxford and Cambridge: Blackwell.

—— (ed.) (1997) *Jean Baudrillard: Art and artefact*, London, Thousand Oaks, CA, New Delhi: Sage Publications.

Index